Mission Furniture

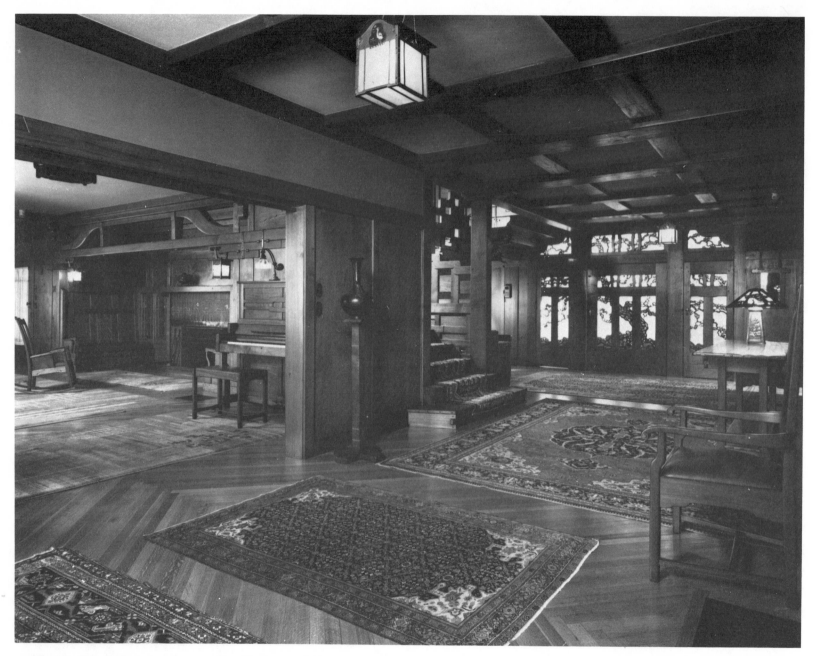

*Marvin Rand photograph, courtesy Greene and Greene
Library, The Gamble House.*

Mission Furniture

Making It, Decorating With It,

Its History and Place in the Antique Market

Jerome and Cynthia Rubin

With an introduction by Robert Bishop
Director, The Museum of American Folk Art

CHRONICLE BOOKS · SAN FRANCISCO · A PRISM EDITION

This book is dedicated to our parents
Gladys and Mike
Esther and Sam

Book and cover design by Wendy Cunkle Calmenson
Composition by Hansen & Associates

Frontis: Entry and Living Room/The David B. Gamble House, 1908; 4 Westmoreland Place, Pasadena, California 91103. Architects Greene and Greene.

Front and back cover photographs: The Brant Ski House, Architect Venturi & Rauch, Philadelphia; reproduced by permission of Sandra and Peter Brant.

ISBN: 0-87701-169-9

Library of Congress Cataloging in Publication Data

Rubin, Cynthia.
 Mission furniture.

 "A Prism edition."
 Bibliography: p.
 Includes index.
 1. Furniture making—Amateur's manuals. 2. Arts
and crafts movement. I. Rubin, Jerome, joint author.
II. Title.
TT195.R8 684.1′042 79-24376
ISBN 0-78810-169-9

Chronicle Books
870 Market Street
San Francisco, CA 94102

Contents

Introduction

Appreciation for American Mission, or Arts and Crafts, furniture is a relatively new phenomenon. Only within the last few years have people begun seriously to collect and study the deceivingly simple oak pieces made during the late nineteenth and early twentieth centuries by Gustav Stickley, Elbert Hubbard, and Charles Limbert, and their numerous contemporaries.

Serious scholars have expressed widely differing theories about the origins of the Mission style. One idea is that American Mission furniture probably originated in 1894 when the Second Jerusalem Church was built in San Francisco, California. Lacking funds to purchase furnishings, the congregation built chairs themselves and used these instead of the more usual pews. Dora Martin, a prominent decorator of the period, noticed the pieces and mailed a letter to Joseph McHugh, a New York furniture manufacturer, telling him about them. McHugh borrowed the idea and used fumed or smoked ash for his first rectilinear pieces. Soon, however, he developed fumed oak which was ultimately to be the most popular material used to create furniture in the new style. Since the California church had been called a "mission church," McHugh capitalized on the idea of Franciscan brothers making benches for their adobe mission. It was a romantic bit of public relations that helped produce sales. Thus, his product was called "Mission," as was the furniture of many other manufacturers. People liked the name, and it stuck.

Other scholars have traced the Mission style to Arts and Crafts prototypes created by Charles Rennie Mackintosh (1868-1928) of Scotland. Certainly Mackintosh and England's William Morris (1834-1896) were important innovators in the rejection of excessively ornamented and ornately carved furniture of the late Victorian period. Following their lead, the now-famous American, Will Bradley (1868-1962), brought their ideas to an ever-widening audience through his designs for specific pieces of furniture as well as room interiors which were published in Edward Bok's *The Ladies Home Journal* in the early 1900s.

A pervasive romance about the handcrafting of Mission furniture is certainly erroneous, for much of it was mass-produced with the aid of new machinery developed during the Industrial Revolution. This machinery altered manufacturing techniques during the second half of the nineteenth century.

All three of the best known American Mission furniture manufacturers—Stickley, Hubbard, and Limbert—expressed great pretensions about themselves and their work. Gustav Stickley (1857-1942), probably the most influential and respected manufacturer of Mission pieces, wrote in 1913: "Most of my furniture was so carefully designed and well proportioned in the first place, that even with my advanced experience I cannot improve upon it." Stickley initially began work on his square-cut, hand-finished "Craftsman" pieces in 1898, and at the Furniture Exposition in Grand Rapids, Michigan, in 1900, he first presented his designs to the public. Stickley's rebellion against the Victorian "reign of marble tops and silk upholstery" was an immensely popular one, and before the demise of his "empire" in 1915 he attracted not only countless followers but also numerous imitators. During the "Craftsman" heyday, Stickley's activities were expanded to include Craftsman Workshops near Syracuse, New York; the Craftsman Farms in New Jersey; *The Craftsman* magazine; and the Craftsman Building in New York City, where all forms of the decorative arts were shown. This Craftsman center also contained a home-builders' exhibit, a library, and a lecture hall.

Elbert Hubbard (1856-1915), one of Stickley's most successful competitors, established a "commune" at East Aurora, New York, where young people could find "congenial employment, opportunity for healthy recreation, meeting places, and an outlook into the World of art and beauty." Craftsmen who worked on *The Roycrofts*, a publication named after two 17th-century English printers; on *The Philistine*, a second publication; and in the numerous furniture shops enjoyed the privilege of being exposed to the benevolent autocrat whose motto was "Not how cheap, but how good." Hubbard successfully disguised the fact that he was really a huckster at heart. With an eye ever toward the profit column on his monthly balance sheet, he managed to parlay his do-gooder activities with astonishing adroitness. Hubbard's personal activities were brought to an abrupt end, for he died with the sinking of the *Lusitania* in 1915.

At first in Grand Rapids, Michigan, and finally in Holland, Michigan, the Limbert Arts and Crafts Furniture Company, under the leadership of Charles P. Limbert (1854-1923), made pieces with production techniques that the firm claimed had their origins in the far past. "Limbert furniture is made by the Dutch at quaint Holland in America. The evils of an ever growing cosmopolitan situation at Grand Rapids recently has caused the firm to move westward to a more picturesque and secluded location where workmen are free from the excesses of city life."

English manufacturers of Mission furniture called their products "quaint." The term reappears in numerous advertisements placed during the early 1900s by American department stores in *The Ladies' Home Journal* and other large circulating magazines. Bloomingdale's, the New York firm, offered in 1914: "A white enamel tea table (in the Mission style) designed for a girl's room. It is unusual and quaint."

Mission furniture represents an area of great interest to today's collectors, for some of it was handcrafted, and it satisfies the requirements of the purist who rebels against mass-produced furniture. Even those pieces that were assembly-line products have a distinctive style that makes them of special interest to those seeking furniture with clean lines. Mission furniture is still available in antique shops and while the signed and labeled pieces have increased in value rather dramatically, unsigned pieces are available in a surprising quantity at reasonable prices. Mission furniture is timeless in style and blends successfully in a contemporary setting. Already large private collections have been formed as indicated in this book and museum curators with forward-looking ideas are eagerly gathering pieces for institutions that are devoted to the preservation of America's artistic and social history.

Mission furniture often represents the last examples of hand-craftsmanship in the American decorative arts.

Robert Bishop
November 1979

A History
of the Style

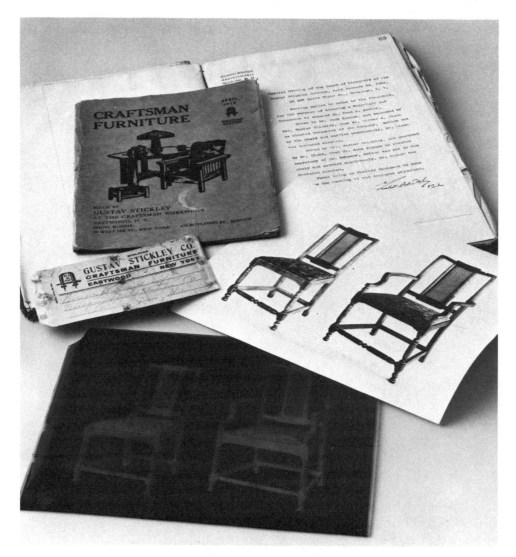

Original catalogues and ephemera are important in identifying furniture and fixtures. (Courtesy, Henry Francis du Pont Winterthur Museum Library)

With its appearance in the first issue of *The Craftsman* magazine, Gustav Stickley's United Crafts Workshop of Eastwood, New York began a chapter in the American decorative arts which Stickley hoped would gain the "sympathy and co-operation of a wide public." This new company was a guild of cabinet makers, metal workers, and leather workers, who had banded together for the production of household furnishings.

Their goal was to produce articles in their workshops which would justify their creation and serve an important use in the household, either by adding to the convenience of daily living or by "furthering the equally important object of providing agreeable, restful and invigorating effects of form and color"[1] as a background to the stress and vicissitudes of daily life. The leitmotif throughout all of Stickley's work was the hope to create a national and perhaps even universal art, adjusted to the needs and desires of the era.

In addition, there was supreme in his philosophy the need to unite, in one person, the designer or artist with the workman. In other words, there was to be no dichotomy between theory and practice. This principle was put continually into practice in the workshops, where the master executed with his own hands what his brain had conceived.

In its attitude toward art and the artisan, Stickley's philosophy was parallel to the thinking and work of the great designer and socialist thinker William Morris. Morris was a man for all seasons. To students of literature, he is considered an innovator, and his writings and poetry have been an inspiration to countless readers. In 1858, Morris published his first poetical work, *The Defence of Guenevere and Other Poems*, a moderate success. He later wrote *The Life and Death of Jason* and the three-volume set, *The Earthly Paradise*, a series of narrative poems which immediately affirmed his literary reputation. During 1870, he was learning to read Icelandic for his translation work on the sagas culminating in the publication of *The Story of Sigurd the Volsung* (1877), considered to be his masterpiece.

To students of art, he revolutionized the British national school of painting. From his relationship with the Pre-Raphaelite Brotherhood, an artistic movement founded in 1848 to find an alternative to outright materialism, he went on to evolve a system of household art which, Stickley said, "largely swept away the ugly and the commonplace from the English middle-class home."[2] Indeed, many of his wallpapers, fabrics, tapestries and pieces of furniture are still in use and continue to be copied for today's household interiors.

Morris was born of wealthy parents. His father, a London banker, was able to provide the Morris children with great educational and social advantages. Because William had been destined by his parents to a life in the Church, he was educated in a parochial environment. Here, after developing a unique place in the student body, he was able to cultivate his own individual taste. The school library at Marlboro College was rich in works on archaeology and ecclesiastical architecture. Through his resolute study of these disciplines, he became an authority on English Gothic and a preservationist toward England's medieval cathedrals and churches.

Leaving Marlboro, he passed under the tutelage of a highly cultivated clerical teacher. Responsive to this new invigorating influence, Morris developed into a beyond-average classical scholar.

But the decisive moment of his life occurred in June 1852 when, on taking the matriculation exam for Exeter College of Oxford University, he sat next to Edward Burne-Jones, who was to become his lifelong and intimate friend.

The atmosphere of Oxford reinforced his interest in medieval thought and culture. Concerning the ambience of the university town, he wrote later in life that "there are many places in England where a young man may get as good book-learning as in Oxford; but not one where he can receive the education which the loveliness of the grey city used to give us."[3]

His tendency toward medievalism was further strengthened by a study-tour of the French cathedral towns of Rouen and Amiens, and by the detailed study he made of the legends of King Arthur and the Knights of the Round Table.

The development of his social and political ideas was slower than his advancement in literature and art. However, he planned to organize a social brotherhood with some of his friends, including Burne-Jones—a plan which was a direct result of Morris's study of the art of the Middle Ages.

His interest in the common man and the human condition became significant. And, upon receiving his baccalaureate degree, instead of entering the church, he apprenticed himself to an Oxford architect. It's difficult to realize today the disappointment such a decision would have meant to his family. For, at this time, men following artistic pursuits were considered Bohemians. Painters were at the lowest rung of the social ladder, but architects were not far behind.

Stickley wrote, "It would seem that in so choosing [architecture as a profession], Morris vaguely felt that by force of his commanding intellectual, moral and personal influence he was destined to redeem and to elevate the then denationalized English decorative arts."[4]

Morris's apprenticeship to G. E. Street, a major architect of the Gothic Revival, lasted only nine months. His architectural studies were never put to extensive use; however, he was largely responsible for the planning, in 1859, of his first home, Red House at Upton, County Kent. The household arts for which England became famous in the late nineteenth century were greatly influenced by this home Morris built for himself and his bride. He employed his friend and fellow apprentice, Philip Webb, in the project, although Stickley later explained that Webb did little else than carry out Morris's plans for the interior design and furnishings.

The past dreams of a brotherhood became a reality when Morris & Company was formed as a group of artists pledged to produce beautiful things. Included among its members were Madox Brown, painter; Dante Gabriele Rossetti, artist and financier; Edward Burne-Jones, perpetuator of the Pre-Raphaelite tradition; Philip Webb, builder and designer; and Charles Faulkner, craftsman and accountant.

At first, the main projects were ecclesiastical decoration. The prevailing aesthetic revival in London churches had created a demand for murals, stained glass, tiles, carving, metal work and altar embroideries. In the decade 1860-1870, the Morris firm executed windows for Salisbury Cathedral and the college churches at Oxford and Cambridge. At the same time, experiments in tapestry making and cabinet work were being carried on. Dyeing, weaving and printing were other crafts that the Morris firm practiced and improved upon.

As a dye colorist, Morris ranks among the best. Also, his attainments in the field of tapestry are especially

remarkable. Taking details from rare books, he translated these details into weaves and gradually became an expert workman, devising new techniques and improvements along the way. Indeed, it has been said that he revived the almost extinct art of fifteenth-century weaving.

Morris's architectural studies had led him to the politics of socialism. He organized the Society for the Protection of Ancient Buildings—an association committed to prevent wanton destruction and overzealous restoration of early English buildings—and found himself circulating petitions and speaking out on controversial issues. This experience led him to re-examine his ideas on both art and politics. He decided that before an industrial society could produce objects as fine as medieval ones, the society itself must be re-created and given new ideals. With the Socialist movement, he hoped to make improvements in the economic conditions of his country. However, his interest began to weaken around 1890 as the stress of his labors took its toll on his health. He devoted the later years of his life to the revival of fine printing.

Technological advances in presses and typesetting had degraded the art of printing, but Morris's Kelmscott Press reaffirmed the artistic principles of the Gothic manuscript. Hand production became more important than easy, cheap manufactures. Morris resolved to create modern books equaling those of the fifteenth century. And, during the brief activity of the Kelmscott Press, it issued over fifty books printed on a hand press, on handmade paper, bound by hand and printed with typefaces designed by Morris himself. His achievement in creating new interest in quality book production and design cannot be underestimated.

In the full activity of his labor, Morris had drawn the portrait of his ideal craftsman, and in it we can recognize his own likeness. "The true workman," he said, "must put his own individual intelligence and enthusiasm into the goods which he fashions. He must have a natural aptitude for work so strong that no education can force him away from his special bent. He must be forever stirring to make the piece at which he is at work better than the last. He must refuse at anybody's bidding to turn out,—I won't say a bad,—but even an indifferent piece of work, whatever the public wants, or thinks it wants. He must have a voice, and a voice worth listening to, in the whole affair."[5]

GUSTAV STICKLEY

Gustav Stickley was born into a farming family in 1857 at Osceola, Wisconsin. Here was the background for his love of home and nature and his almost religious love of wood. He said, "As a farm boy in Wisconsin, I used to make wooden ax helves, yokes for the oxen, runners for the sleigh—whatever happened to be needed for the task in hand. In fact, in the making of these rough farm implements lay the germ of what I have accomplished in later years."[6]

After the farm, he took up stone masonry. His difficult daily labor with this hard material made him even more responsive to the inherent qualities of wood. At age sixteen, he learned the cabinetmaker's trade and found wood's varied grains, textures, and form an endless feast of beauty, which filled him with enthusiasm for his work.

In 1884, Gustav and his two younger brothers, with the help of an uncle, opened a wholesale and retail furniture store in Binghamton, New York. Stickley became involved with many facets of the furniture business.

His dealings were complex and numerous, but we do know that in 1898 he bought out his partner and formed the Gustave[7] Stickley Company in Eastwood, New York, a suburb of Syracuse.

The Craftsman Workshops, part of the Company, were originally modeled after the guild system, but Stickley soon found that the ideal he was so enamored of was of little practical use. After two years of experimentation, he turned to a traditional method of running the business.

In that year, he went to Europe for the first time, already drawn to the new ideas and designs of modern European furniture. While in England, he met Charles F. A. Voysey, and in Paris he was introduced to the leading figures of the new *Art Nouveau* style at critic and art dealer Samuel Bing's gallery, the city's clearinghouse for the *avant garde*. From there, Stickley brought back to America a wide range of decorative objects, including jewelry, glass, furniture, ceramics, textiles and metalwork.[8]

In 1900, two of Stickley's brothers left his workshop and started the L. & J. G. Stickley Company in Fayetteville, New York. There, later imitation and emphasis on the Stickley name was a constant cause of annoyance to Gustav, who by 1900 was using the term "Craftsman" and the symbol of the medieval joiner's compass.

That same year, Craftsman furniture was introduced to the public at a furniture exposition in Grand Rapids, Michigan. Stickley felt its success showed he "had not been mistaken in supposing that this—the first original expression of American thought in furniture—would appeal strongly to the directness and common sense of the American people."[9] Indeed, there is a frankness of construction evident in every piece. Pins, wedges,

(text continued on page 11)

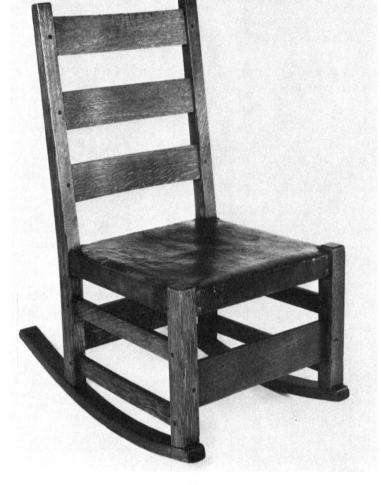

Sewing rocker, Craftsman Workshops, quarter-sawed white oak with leather seat, circa 1910. Height 31", Seat 16" × 16". (Photograph courtesy Jordan-Volpe Gallery.)

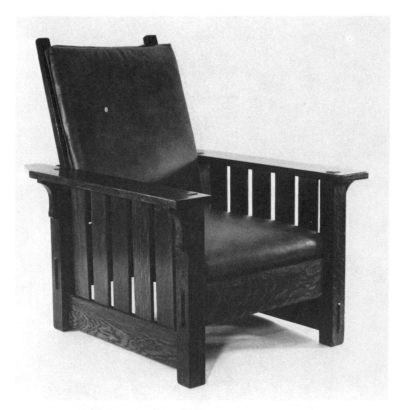

Reclining chair, Craftsman Workshops, quarter-sawed white oak with leather spring seat and cushion, circa 1910, height 40", width 23", depth 27". (Photograph courtesy Jordan-Volpe Gallery.)

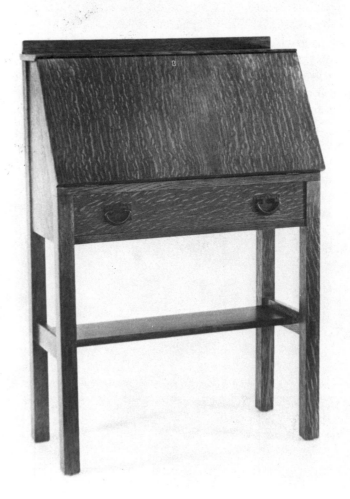

Dropfront desk, Craftsman Workshops, quarter-sawed white oak with hand-hammered copper hardware, circa 1907, height 39", width 30", depth 14". (Photograph courtesy of Jordan-Volpe Gallery.)

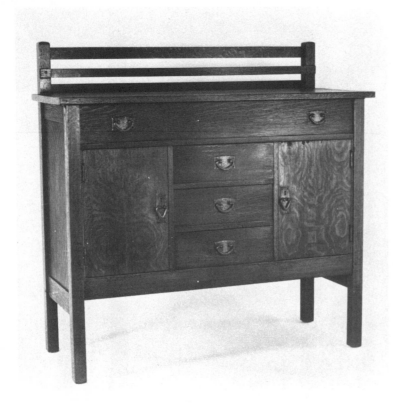

Sideboard, Gustav Stickley, quarter-sawed white oak with hand-hammered copper hardware, circa 1909, height of table 38", width 48", depth 18", top of plate rail 48". (Photograph courtesy of Jordan-Volpe Gallery.)

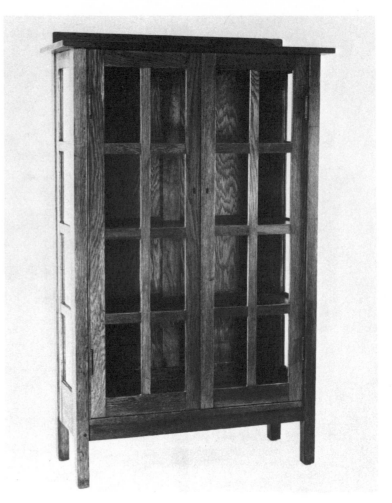

Double-door bookcase, Gustav Stickley, quarter-sawed white oak, height 57", width 36", depth 14". (Photograph courtesy Jordan-Volpe Gallery.)

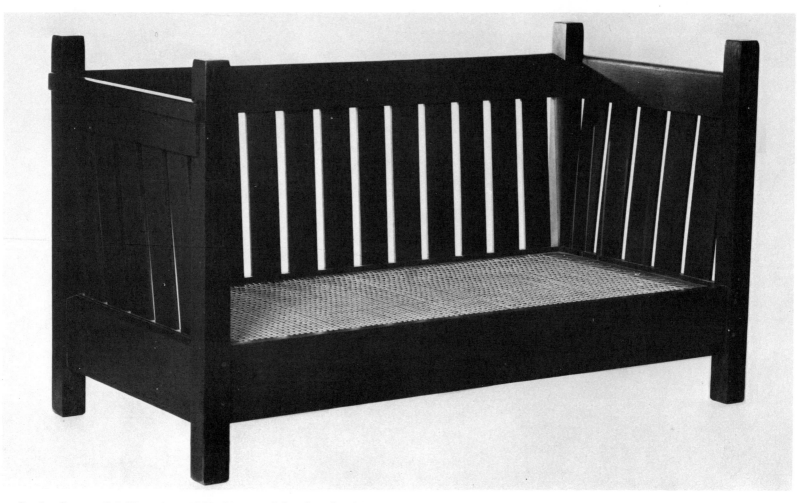

*Settle, Gustav Stickley, circa 1902, large red decal, oak, 39"
high, 70" wide, 33" deep. (Photograph courtesy Robert
Edwards Gallery.)*

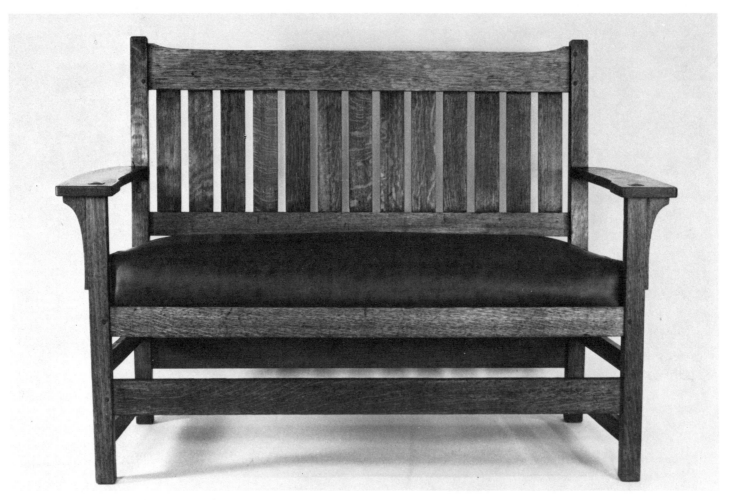

*Bench settle, L. & J. G. Stickley, quarter-sawed white oak
with leather seat, circa 1906-1912, height 36", width 48",
depth 20". (Photograph courtesy of Jordan-Volpe Gallery.)*

In the Middle Ages, each master-workman adopted some device or logo, which he displayed on every object of his creation. Ian van Eyck, a Flemish painter in the fourteenth century, employed the words "Als ich kanne" (if I can) on his canvases, undoubtedly as an inspiration toward excellence. Later, when William Morris visited the Low Countries as a young man, he found this legend and adapted it for his own. He used it in French, "Si je puis."

Stickley decided to use the same legend in modern Flemish form, "Als ik kan," together with a joiner's compass, a primitive but distinctive tool of the craftsman woodworker. In 1901, this appeared, along with Stickley's signature and the date, branded on every object produced in the workshop of the Craftsman Guild. Later, in 1909, it also appeared, in a slightly different form, on the furniture and its separate price tag. As shown here, the tag was supposed to remain affixed to the piece in the retail outlet after it left the workshop, thus insuring a uniform price for all Craftsman furniture. However, the local dealer west of Denver was advised to add any additional freight charges, as necessary.

mortises and tenons appear often; in this way, the pieces are not unlike the furniture of medieval times. Massive size and rectilinear structure indicate a rational and orderly philosophy behind the construction. This original new design was a rejection of the poorly constructed and over-ornamental furniture common to the Victorian period. Later, in 1903, when designer Harvey Ellis worked for Stickley, a more decorative and more delicate element was introduced into the furniture's design, demonstrating the influence of the English Arts and Crafts stylists of the day, such as Baillie Scott, Charles F. A. Voysey, and the Scottish designer who is becoming increasingly renowned, Charles Rennie Mackintosh.

In 1901, Stickley shared booth space with the Grueby Faience & Tile Company of Boston at the Pan-American Exposition in Buffalo. His prices were moderate and reaction was greatly encouraging.

Later, in October of that year, he produced the first issue of *The Craftsman* magazine, a monthly which began by giving editorial homage to William Morris and John Ruskin. In it, he represented work and opinions of others in sympathy with his own ideas. He felt he reviewed and illustrated what would prove helpful to men and women in America. He encouraged handicrafts and individuality. And, as he became more and more interested in every detail of the home environment, he knew his Craftsman furniture was out of place in an over-ornamental interior, so he provided plans and illustrations of the kind of home that symbolized his ideal. Feeling that the true American likes to know how things are done, he provided details of construction as well as advice on the finish, other furnishings, floor plans and complete decorating schemes.

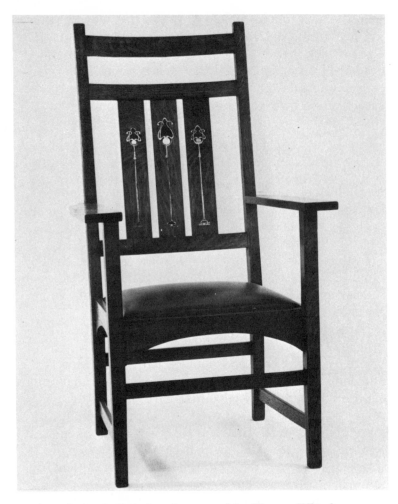

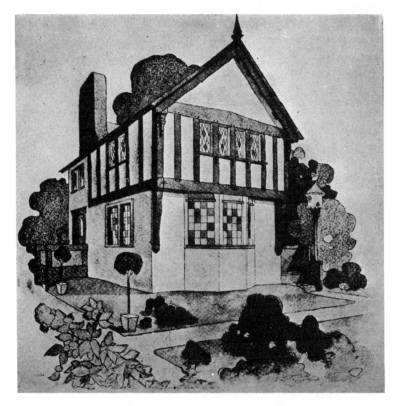

Edward Bok, editor of the Ladies' Home Journal *around the turn of the century, campaigned against what he considered the monstrosities of American design in the nineties. His editorial campaign against "bad taste" promoted such homes as the house pictured, which cost $1,000 to build in 1905.*

Armchair, designed and executed by Harvey Ellis for Craftsman Workshops, quarter-sawed white oak with copper and pewter inlay, circa 1903-1904, height 43", width 24", depth 19". (Photograph courtesy Jordan-Volpe Gallery.)

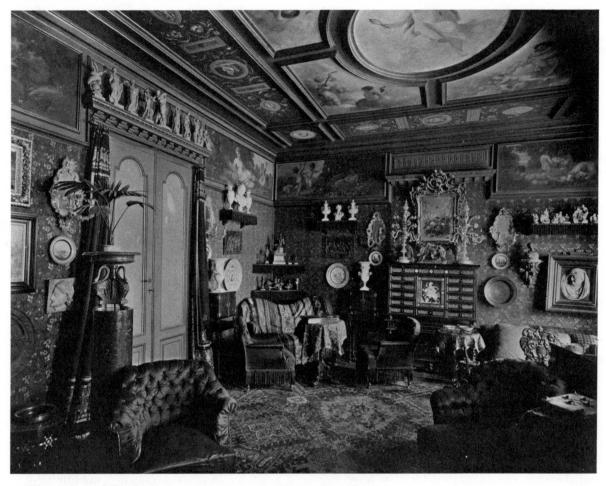

The Arts and Crafts movement was a reaction against the clutter and ornamentation of the Victorian, a style filled with pretense and excessive embellishments, which is typified in this photograph of a Boston parlor, circa 1885. It is a room cluttered with art objects, intricate wallpaper, and modern upholstered "comfortables," and with a ceiling decorated in allegories of Venus. (Reprinted from The Tasteful Interlude *with permission of William Seale.)*

In the beginning, there had been no thought of creating a new style *per se* — only a recognition of the fact that Americans should have in their homes something better suited to their needs and more expressive of their character as a people than imitations of the traditional styles, and a conviction that it is best to go back to plain principles of construction and apply them to making strong, simple and comfortable furniture.

In 1903, Stickley sponsored an exhibition, which was described in a later issue of *House Beautiful*:

The Arts and Crafts Exhibition held at Syracuse, N.Y., in May 1903, under the auspices of the United Crafts, was an adequate representation of the actual state of American handicrafts, and caused intense interest among those who were active in fostering decorative and industrial arts. No pains were spared to make it a great success. The exhibition was held in the Craftsman's Building, the publishing house of "The Craftsman." Through Mr. Gustave Stickley's efforts, the craftsman's workshops are becoming a center of the Arts and Crafts movement.[10]

By 1905, Stickley had outgrown Syracuse as the base for his empire, so he moved to New York City. Only the Craftsman Workshops themselves remained behind.

Once in New York City he continued working; *The Craftsman* magazine continued to be a success. But because of his concern with country living, a sense of homesickness for his Wisconsin surroundings, and his social and moral sense, he purchased land in New Jersey with the intention of setting up a home or farm school for boys, which he named Craftsman Farms. Here Stickley's view of education was to be put into practice. He believed that books were not the most important element in a true education; a boy must learn to work above all. In Stickley's own words, "boys should

Stencil showing wild carrot motif, from The Craftsman *magazine.*

first be taught the ideal and the practice of *doing something useful* with brain and hands, combined with abundant outdoor life. Through *work* the child should learn the necessity for knowledge. Study should be the valued supplement to work, and book-education should accompany, but never precede, the education derived from actual individual experience."[11]

To Stickley, only a farm environment could offer the practical and creative means of development necessary for what he believed to be a boy's proper upbringing. At Craftsman Farms, the boys lived in ideal home conditions, for Stickley strongly felt that no theories could supplant the ideal of a family reared in the individual home, and that education itself could never be divorced from the home environment.

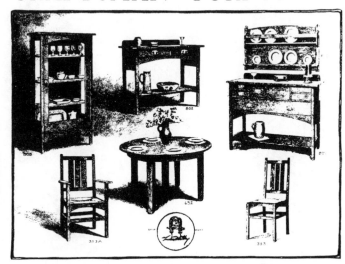
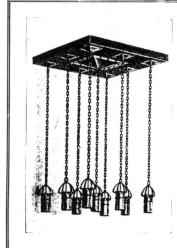

In 1913, Stickley moved his Craftsman enterprises to a large building on East 39th Street, where he had a restaurant; lecture room; the Craftsman Permanent Homebuilders' Exposition—four floors of everything the homeowner would want; floors of furniture display; the magazine's headquarters; and an architectural department. It was a big move, but it came too late.

Stickley's bubble burst in 1915, and he was forced to declare bankruptcy. He tried to compete with other furniture manufacturers by introducing new lines, including "Chinese Chippendale" and "Chromewald," a painted furniture with fumed antique finish in blue, gray or brown. But it was all to no avail. Large-scale manufacturers with similar designs and cheaper prices had captivated the American consumer. *The Craftsman* ceased with the December 1916 issue and Stickley was out of business. Obviously, the American people that he counted on so much no longer gave him the encouragement and backing that he needed.

ELBERT HUBBARD

Stickley's chief competitor had been Elbert Hubbard and his Roycrofters. Hubbard, a singular and flamboyant personality who always dressed in a long black Prince Albert coat with flowing Windsor tie, Stetson hat and long hair, had previously been a partner in the Larkin Soap Company. In 1893 he sold his interest and traveled to England. There he visited William Morris's Kelmscott Press and watched the production of hand-illuminated books, tapestries and objects of hammered silver and copper. He also gathered material for his first volume of *Little Journeys to the Homes of the Great*, intending to launch a literary career.

Upon his return, he founded the Roycroft Shop, its name taken from Samuel and Thomas Roycroft of London, who produced fine bindings and books in the late seventeenth century. In Hubbard's own words:

In choosing the name "Roycroft" for our shop we had these men in mind, but beyond this the word had a special significance, meaning King's Craft—King's craftsmen being a term used in the Guilds of the olden times for men who had achieved a high degree of skill—men who made things for the King. So a Roycrofter is a person who makes beautiful things, and makes them as well as he can.[12]

The Roycrofters was the legal name of Hubbard's institution; it was a corporation whose shares were distributed among the workers. Only Roycrofters could hold shares and anyone who quit work was obliged to sell his shares back to the concern. The co-operative plan worked well. Each worker felt a deep sense of personal diligence, loyalty to the institution, and fraternity with all concerned.

In the first Roycroft book, *The Song of Songs*, the pattern was set. Books were to be admired as much as to be read. As Morris taught, this meant going to pre-machine sources for all paper, inks, type design, and decoration. Hubbard took much of this from the Morris example, and the Kelmscott-type book was brought into the average home thanks to his perseverance, but he added some self-serving personal touches. The note at the end of *The Song of Songs* reads: "And here, then, is finished the noble book being a study and reprint of the Song of Songs: which is Solomon's taken from the Holy Bible. Printed after the manner of the Venetians with no power save that of the Human Muscle at the Roycroft Printing Shop, that is in East Aurora,

THE ROYCROFT SHOP IN EAST AURORA

New York. Begun on September, the third day, 1895, and finished—thank God!—on January, the twentieth day, 1896."[13]

However, the important thing is that Hubbard emphasized the book as an art form, reviving and continuing the line of tradition in American fine printing. He often used hand-illuminated initials, distinctive borders, handmade paper, limp leather bindings and colophons.

The illuminating of initials and title pages was a revival of a lost art, made famous by the monks of medieval time. Hubbard was proud of this hand workmanship and boasted how "the British Museum and 'Bibiotheke' [sic] at the Hague have deigned to order specimans [sic] of our handicraft."[14]

Within a few years, a variety of hand-crafted products were being produced in addition to books and magazines: pottery, hammered copper, tooled leather artifacts,

The Greatest Mistake You Can Make in Life is to be Continually Fearing You Will Make One

ELBERT HUBBARD

furniture (with pieces incised with an orb-and-cross symbol or with the Roycroft name), stained glass, lamps, wrought-iron hardware, and baskets.

People from all walks of life came to East Aurora to be part of this communal experiment and to take part in its industries. In the early 1900s, Hubbard wrote that in a single year, twenty-eight thousand people had visited the Roycroft Shop, representing every state and territory of the Union, including Iceland, New Zealand and the isle of Guam. Over three hundred people were on the payroll, and three monthly publications —*The Philistine*, *Little Journeys* and *The Fra*—were being printed and distributed, with *The Philistine* having a circulation of over a hundred thousand copies a month.

As the Roycroft enterprises expanded, Hubbard seemed to be enjoying it all. He was being creative, and the public loved it. He was to learn exactly how much they loved it when he published what would become his most renowned piece of writing, "A Message to Garcia."

At first, it seemed the typical Hubbard preachment, written hastily after the Spanish-American War and published in the March 1899 issue of *The Philistine* without even a heading.

What was all the excitement about? Hubbard had written about a "fellow named Rowan" who carried an urgent communication to General Garcia of the Cuban revolutionary forces. It was a difficult assignment. Rowan had to go into the jungle, through mud and into the mountains to find the general. The story itself was short, but the moral was long.

"The point I wish to make is this: McKinley gave Rowan a letter to be delivered to Garcia; Rowan took the letter and did not ask, 'Where is he at?' By the eternal! There is a man whose form should be cast in deathless bronze and the statue placed in every college of the land. It is not book-learning young men need, nor instruction about this and that, but a stiffening of the vertebrae which will cause them to be loyal to a trust, to act promptly, concentrate their energies: do the thing—'Carry a message to Garcia.' "[15]

The lesson was plain. At a time when indifference and

slipshod work were becoming more and more the norm, Hubbard advocated a willingness to do the job at hand without needless questions and delays. The incompetence and carelessness of the individual must be eliminated, or else that individual must be relieved of his job.

It was a masterpiece of didacticism that people understood and wanted others to learn from. Heads of corporations found it a down-to-earth homily with which they could instruct their workers. The New York Central Railroad ordered a million reprints. Other businesses followed suit. Judges read it before the prosecuted; generals taught it to their soldiers. It was distributed to workers all over the nation. Hubbard's name became a national byword.

For his own personal lifestyle, the theme remained the same. Work was an ethic. To work, and work well, was an integral part of his philosophy, and it was the most instrumental element in making the Roycroft Shop the success that it was.

In his lectures, Hubbard described his community as an enterprise dedicated to beauty, truth and goodness. He would often reiterate that parolees and orphans had been among his best recruits; people enjoyed hearing about his rehabilitation-through-hard-work theories. He gave the impression (and rightly so) that his commune cared about its people. That was the difference between his extended environment and others.

But Hubbard's life, both private and public, had all the vicissitudes one might associate with such a flamboyant figure. His love for the theatrical, his emphasis on mass media and advertising, his endless lectures and writings were all part of the Hubbard mystique. His detractors viewed his philosophy and his ego-centered lifestyle with doubt, and suggested that it was

perhaps the profit motive, rather than the work ethic, that he lived by.

In 1915 the Hubbards decided to go to Europe. The Roycroft enterprises were doing well, and Hubbard wanted to investigate the war scene himself. After a joyful gathering of the Roycrofters, at which the management of the business was turned over to the Hubbards' son, Bert, both Elbert and Alice left for Europe on the *Lusitania*. When it was torpedoed and sunk by a German submarine on May 7th, the Hubbards died along with more than one thousand other passengers and crew. Nothing is known of the Hubbards' actions during the short time when the ship was sinking without being able to load and launch enough lifeboats. One survivor later reported he thought he had seen them holding hands and heading back to their cabin. The final issue of *The Philistine* dealt with this scene as a deliberate self-sacrifice.

Under the firm management of Bert, the Roycroft industries carried on. But that unique spark of individuality and creativity that had been the nucleus of the Roycroft legacy seemed to have been extinguished. The whole enterprise gradually broke down until it closed in 1932.

AND OTHERS

Hubbard had not been Stickley's sole competitor. Charles Limbert headed a guild of "Holland Dutch workmen" from the town of Holland, Michigan, which was appropriately called, at that time, the most typically Dutch settlement in America. There they produced Dutch Arts and Crafts furniture with the solidity of older Dutch designs embodied to fit modern uses.

Limbert Trademark. (Collections of Greenfield Village and the Henry Ford Museum)

True to the ideal of the old masters of cabinetmaking, and unlike modern furniture, Limbert's products did not depend for their beauty on carving or applied ornament, which he felt merely disguised poor workmanship. In his catalog number 119, he states, "Our craftsmen and artists prefer to let their perfect modeling, correct proportions and pleasing outlines, together with the skillful use of plane, saw, chisel and moulding iron tell their own tale . . . and rely upon the natural beauty of the materials and the solidity of their construction to show true art."[16]

Leopold and J. George Stickley, Gustav's brothers, had established their own furniture business in Fayetteville, New York, not far from Gustav's Craftsman Workshops in Eastwood. Although many of their designs seem to be derivative of Gustav's forms, their furniture is now considered by many experts to be on the same level of quality as the products of Gustav's Craftsman Workshops.

The mushrooming demand for this furniture style was responsible for many factories switching production, and manufacturing cheaper and more primitive examples of what we've been looking at. Lifetime Furniture, Stickley Brothers' "Quaint" furniture, and the "Home-Built Arts and Crafts" style, made in sections by the Grand Rapids Furniture Manufacturing Company,[17] are but a few of the myriad imitations of what Gustav Stickley had initiated.

His designs, based on the principles of honesty and simplicity, were a personal reaction to the "badly-constructed, over-ornate, meaningless furniture . . . whose presence in the homes of the people was an influence that led directly away from the sound qualities which make an honest man and a good citizen."[18]

Stickley had done such a fine job of creating a market for his own special style of "Craftsman" furniture that the style became the model for the interiors of office buildings, public rooms, game rooms and the average home. His *Craftsman* magazine not only created sales for his products but also encouraged the spread of his Arts and Crafts philosophy. He felt that if the products pictured in his magazine were able to stimulate a deeper interest in home life and environment, and were able to encourage a greater appreciation for what was beautiful and sincere, then he accomplished something worthwhile. His house designs with their floor plans as well as their practical advice on construction, furnishing and decorative schemes gave his views a channel into the homes of the average person. He felt his work was a movement, not merely an individual enterprise, and that in strengthening honest craftsmanship in every branch of human activity, his ideals would express themselves in the spirit of the American people.

Through its articles on art, architecture, literature and the decorative arts, *The Craftsman* has become an important document of the social history of its time. Stickley's influence on the subsequent leading architects and designers has left an indelible mark on today's design and modern furniture.

FOOTNOTES

1. [Gustav Stickley], "Foreword," *The Craftsman*, Vol. 1, No. 1 (October, 1901).
2. Gustav Stickley, *The Craftsman*, Vol. 1, No. 1, p. 1.
3. Ibid., p. 5: as quoted by Stickley from William Morris's writings.
4. Ibid., p. 7.
5. Ibid., p. 12: as quoted by Stickley from William Morris's writings.
6. Gustav Stickley, "The Craftsman Movement: Its Origin and Growth," *The Craftsman*, Vol. 25, No. 1 (October, 1913), p. 18.

7. In 1904, Stickley changed his name by dropping the final *e* from Gustave.
8. John C. Freeman, *The Forgotten Rebel* (Watkins Glen, New York: Century House, 1966), p. 15.
9. *Catalogue of Craftsman Furniture Made by Gustav Stickley at the Craftsman Workshops* (Eastwood, New York, 1909; reprint, The American Life Foundation, 1978), p. 4.
10. Mabel Tuke Priestman, "History of the Arts and Crafts Movement in America," *House Beautiful*, XX (November, 1906), p. 14.
11. Gustav Stickley, "A Visit to Craftsman Farms: The Study of an Educational Ideal," *The Craftsman*, Vol. 18, No. 6 (September, 1910), p. 641.
12. Elbert Hubbard, *The Roycroft Shop* (East Aurora, New York: The Roycrofters, 1909), p. 6.
13. As cited by Freeman Chapney, *Art & Glory: The Story of Elbert Hubbard* (New York, New York: Crown Publishers, 1968), p. 59.
14. Elbert Hubbard, *The Roycroft Shop*, p. 13.
15. Elbert Hubbard, "Message to Garcia," *The Philistine* (March, 1899) quoted in Freeman Chapney, *Art & Glory: The Story of Elbert Hubbard*, p. 87.
16. *Charles P. Limbert Company Cabinet Makers*, Book No. 119 (Grand Rapids & Holland, Michigan, n.d.), p. 12.
17. In the April 1910 issue of *The Craftsman*, there is an advertisement on p. 147 for Home-Built Arts and Crafts stating that it is the "highest quality at half the retail price." It continues, "So perfect any one can set up and finish. Mere purchase of the finished piece can never give the keen satisfaction which is a part of the simple and easy task of assembling and finishing Home-built furniture. It's delightful recreation." The irony is that at the bottom of the page, Stickley's tag reads, "Kindly mention *The Craftsman*."
18. Gustav Stickley, *Catalogue of Craftsman Furniture*, 1910, reprinted in *Stickley Craftsman Furniture Catalogs* (New York, N.Y.: Dover Publications, 1979), p. 3.

Decorating With
Mission Furniture

Craftsman Farms

Stickley, born and reared in a small farm community in Wisconsin, was naturally influenced all through his life by the environment, training, and ideals of those early days. When he selected the tract of land in New Jersey for his ideal farm home for boys, which was to be called Craftsman Farms, his thoughts instinctively returned to his hard-working but happy boyhood. He wanted to "help them with the fruit of [his] experience, teach them woodcraft and farming, home-building and cabinetmaking, show them how to become a capable, self-dependent group."[1]

The Craftsman Farms School for Citizenship opened in 1913. The boys lived in Craftsman houses, which they helped to build, and the farm products were marketed in the neighborhood.

Stickley felt strongly that "environment teaches where precept often fails."[2] The Farm School included the "ideal of the home" and taught that through hard work a child could learn the necessity for knowledge and truth.

The log house at Craftsman Farms was at first intended to be the clubhouse, but was used instead as the Stickley residence. Photographs of the residence and two shingle cottages appeared in the November 1912 issue of *The Craftsman*. The home is now a private residence; the cottages have been converted into apartments.

[1]*The Craftsman*, Vol. 23, October 1912, p. 119.
[2]*The Craftsman*, Vol. 18, September 1910, p. 638.

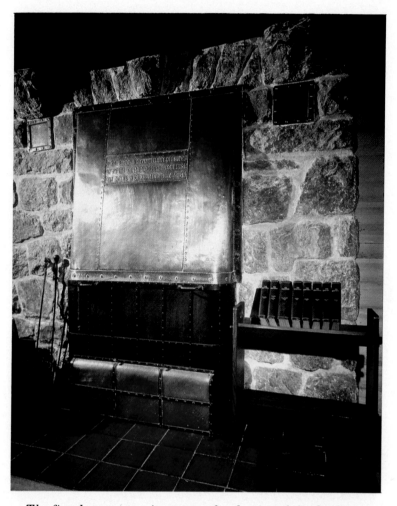

The fireplace was an important focal point of the Craftsman home. Here at Craftsman Farms, the hammered-copper fire hood stands out against the texture of the stonework. It is inscribed, "The dear old farm with pictures of fruit on the dining room wall but nary a bit on the table at all."

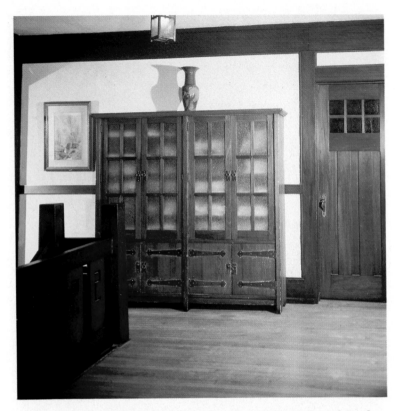

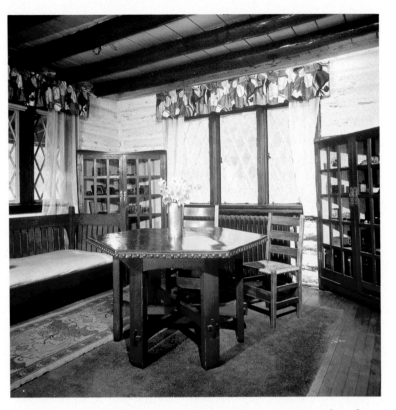

In the Stair Hall: a large oak linen cabinet with amber glass panes and hammered-copper hardware. The honest feeling for the wood, along with the white walls and simple linear wood elements, is reminiscent of a Shaker interior, where harmony and order were the result of the true craftsman's attitude toward his immediate work at hand.

A corner of the living room. All furniture is original to the house, including the custom-built corner bookcases.

(Photographs by Helga Photo Studio, reproduced by permission of The Magazine Antiques*).*

THE LIVING ROOM

In 1905 Stickley began a series of articles in *The Craftsman* in which he featured a certain room, explaining as simply as possible the various interesting features which go to make the room a unit in itself as well as a component part of the whole scheme of a dwelling.

The living room was chosen as the theme of the first article because Stickley considered it the most important room in the house. "A large and simply furnished living room where the business of home life may be carried on freely and with pleasure, may well occupy all the space ordinarily partitioned into small rooms, conventionally planned to meet supposed requirements. It is the executive chamber of the household, where the family life centers and from which radiates that indefinable home influence that shapes at last the character of the nation and of the age. In the living room of a home, more than in almost any other place, is felt the influence of material things. It is a place where work is to be done, and it is also the haven of rest for the workers. It is the place where children grow and thrive and gain their first impressions of life and of the world. It is the place to which a man comes home when his day's work is done, and where he wishes to find himself comfortable and at ease in surroundings that are in harmony with his daily life, thoughts and pursuits."[3]

[3]Gustav Stickley, "The Living Room, Its Many Uses and Its Possibilities For Comfort and Beauty," *The Craftsman*, October 1905, p. 59.

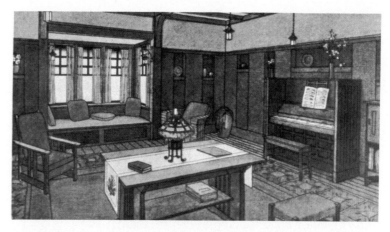

A Craftsman living room showing recessed window seat. Note the honest wood beams which space the ceiling so pleasantly, as well as the paneled wainscot, and the built-in shelves, which give interest to the walls.

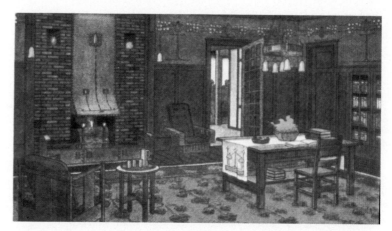

A Craftsman living room where the fireplace is the central feature. The structural variations of a room are endless, but the central point of interest gives the keynote as to both structure and color scheme.

THE DINING ROOM

In November of 1905, Stickley continued with the next most important room, the dining room, "the center of hospitality and good cheer, the place that should hold a special welcome for guests and home folk alike."[4] Instead of fulfilling a number of different and varied functions like the living room, it had basically one purpose.

"A well-arranged dining room, more than almost any other room in the house, rejects any but the absolutely necessary furnishings. If the wall spaces are well divided and the color scheme rich and interesting, there is no need for pictures—which usually seem out of place in a dining room—and the shining array of silver, glass and china on sideboard, shelves or plate-rack leaves nothing lacking in the way of appropriate ornamentation."[5]

[4]Gustav Stickley, "The Dining Room as a Center of Hospitality and Good Cheer," *The Craftsman*, November 1905, p. 229.
[5]Ibid., p. 229.

A Craftsman dining room (top right) with recessed side-board showing tiling above. Two things are important in the formation of the dining room: convenience and cheerfulness. Convenience ranks first, because in a carefully executed home, the work of the household is made as easy as possible.

A Craftsman dining room (right bottom) with built-in sideboard and recessed window. Stickley said that if possible, the dining room should have an exposure that gives it plenty of light as well as air. The windows play an important part in the room's decoration. A bright sunny room may be tempered by a cool and peaceful color scheme in walls and woodwork.

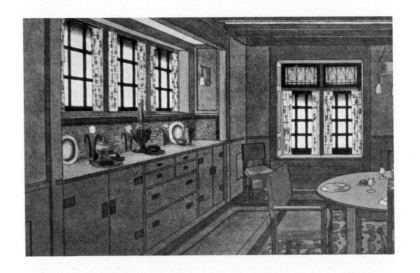

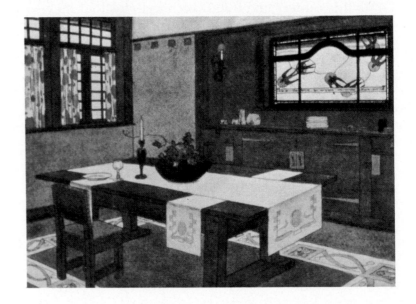

The Brant Ski House

This ski house in Colorado has been built for a Connecticut couple, Sandra and Peter Brant, and a friend. It is designed to serve large numbers of weekend guests, who are lodged in five bedrooms as well as on built-in furniture which doubles as sleeping accommodations.

The fourth-floor living room is an attic-like space where groin vaults are adorned on three sides by large dormer windows and on the fourth by a large imposing fireplace. Its direct but richly textured interior is shown off to the fullest with Mission furniture, wicker of the same period, and Arts and Crafts pottery.

The Mission pieces emphasize the Arts and Crafts element, which is further referenced in the use of natural woods for all surfaces. This is a home whose whole *raison d'être* seems to underlie the principles established by Morris that beauty does not imply elaboration or ornament, but employs only those forms and materials which make for "simplicity, individuality and dignity of effect."[6]

[6][Gustav Stickley], "Foreword," *The Craftsman*, Vol. 1, No. 1, October 1901, i, as quoted by Stickley, referring to Morris's principles.

Second floor. The stairs to the third floor (top right) are behind this cut-out wooden screen which, with its fascinating texture, could double as a piece of art. (Photo by Steve Izenour)

Gustav Stickley's Mission furniture and art pottery dominate the spacious living room (bottom right) where an imposing "ski-lodge" fireplace is a focal point. The interior is finished in horizontal cedar siding with a wide-plank pine floor. (Photo by Steve Izenour) See back cover for a view of the stairway leading to the living room.

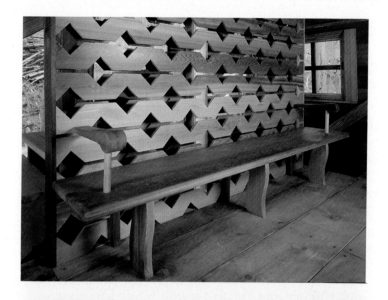

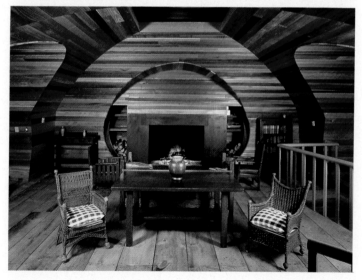

Architect Venturi & Rauch, Philadelphia. Reproduced by permission of Sandra and Peter Brant.

The Cathers House

Beth and David Cathers have been immersed in the Arts and Crafts period ever since they first saw the Princeton University exhibition in 1972. For them, there has been a continual upgrading of their collection, including a recent purchase of a rare, Harvey Ellis-designed chair inlaid with copper, pewter, and woods. Ellis worked less than six months at Stickley's Craftsman Workshops, producing forms inlaid in imaginative designs.

In outfitting their home, the Catherses have acquired some outstanding lighting fixtures and decorative accessories, as well. They both continue to study the movement through Beth's involvement at the Jordan-Volpe Gallery and David's work on an authoritative text on Stickley and Roycroft furniture.

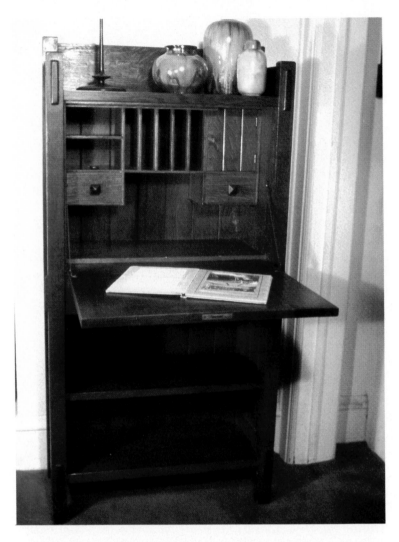

Early Gustav Stickley desk, with accessories of Fulper pottery and a brass candlestick designed by Robert R. Jarvie, circa *1901.*

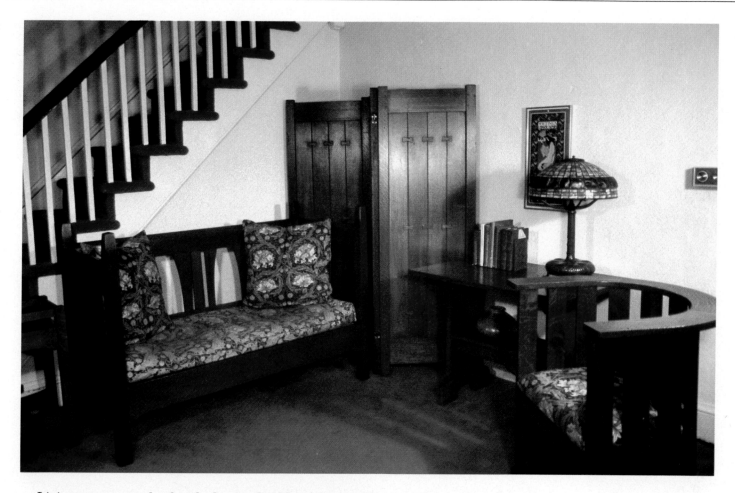

Living room: a settle of early Gustav Stickley design, with Liberty fabric cushions copied from William Morris's design, Jungle Marigold. Screen from Craftsman Farms. Tiffany turtleback lamp; early Gustav Stickley library table; Fulper pottery; Roycroft books; Tiffany bookends. On the wall is a poster (advertising Whiting's Ledger Papers) designed by Will Bradley, 1896, and an unusual curved-back chair, unsigned.

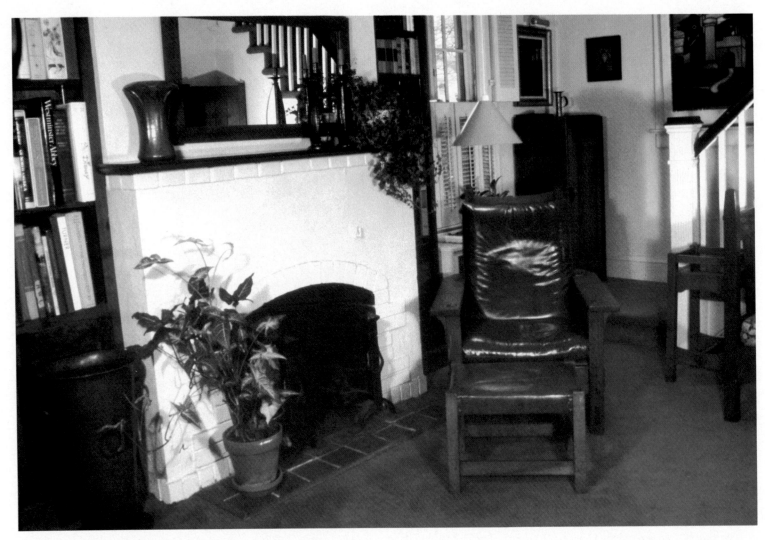

Living room: a Morris chair dominates this setting. Above the fireplace are decorative pieces of the period and a mirror, believed to be a Gustav Stickley piece.

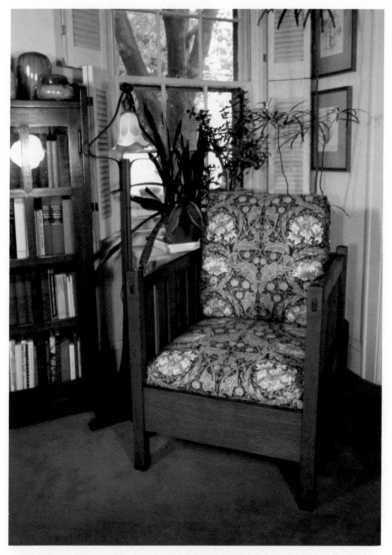

Corner of the living room with Gustav Stickley armchair, circa 1910; the fabric matches the settle seen in another view.

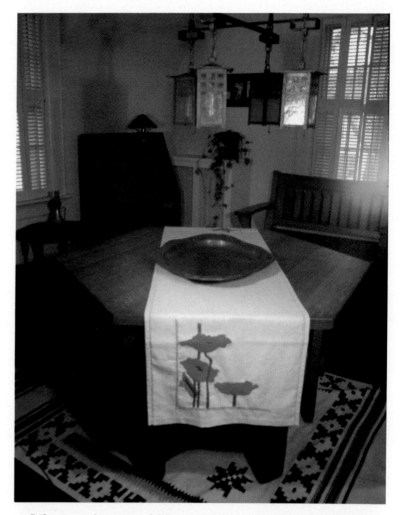

Library: a hexagonal library table, circa 1905, has a reticulated tray with mother-of-pearl insets, unsigned; a modern table scarf with poppy motif taken from The Craftsman *magazine; an extraordinary Gustav Stickley light fixture with cross braces of oak, hammered copper plates, iron lanterns, and hammered light green glass.*

The Dillof Residence

Elaine Dillof wears many hats. As a wife, mother of four children, and Westchester antiques dealer, she first discovered Mission designs in about 1971 when she was trying to spot the next trend in collectibles. Her big rambling home houses an eclectic collection of Americana, folk art, art deco, and Arts and Crafts. The lush colors and myriad patterns demonstrate how versatile Mission really can be.

Her frequent trips to Maine have netted Elaine many quilts, modern primitive-type carvings, and unusual bits of Americana, which are shown off in this active home to their best advantage in the midst of a sedate Gustav Stickley oak realm.

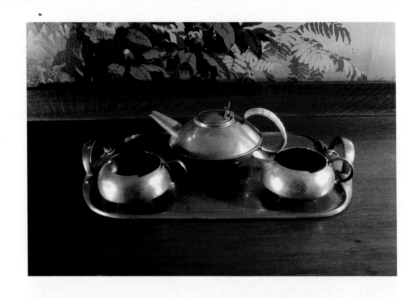

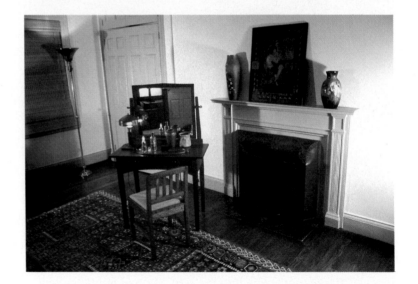

English pewter Arts and Crafts tea set (top right).

Bedroom (bottom right): an unusual leather fireplace screen. On the left of the mantel is a Rookwood vase, signed Laura Fry, 1890s; on the right, a studio piece, signed Louise McLaughlin, Cincinnati, 1878. The painting is a door to a cabinet, probably English. The dressing table holds a number of Arts and Crafts accessories: a Roycroft lamp; turquoise Van Briggle vase, 1906; eggplant-colored Rookwood vase, 1920; Roycroft tray.

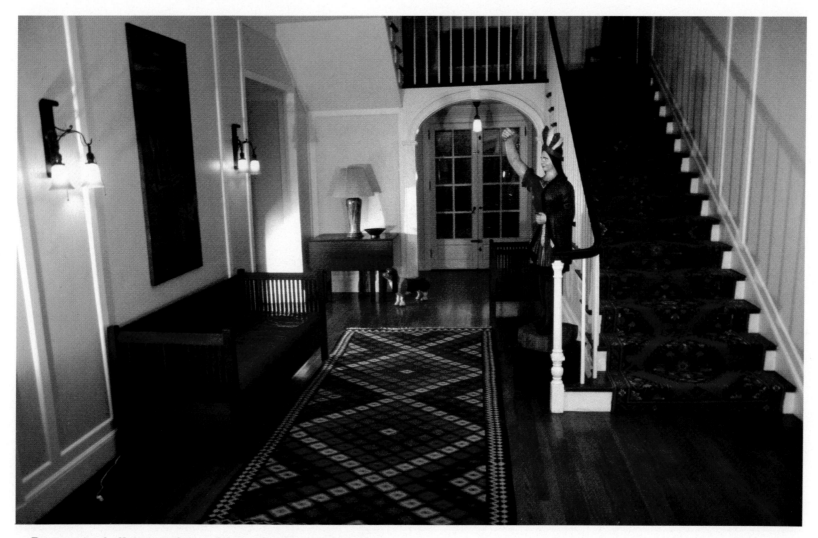

Downstairs hall (top right): a Gustav Stickley settle faces a cigar-store Indian. The Arts and Crafts sconces were recent finds at an antique show.

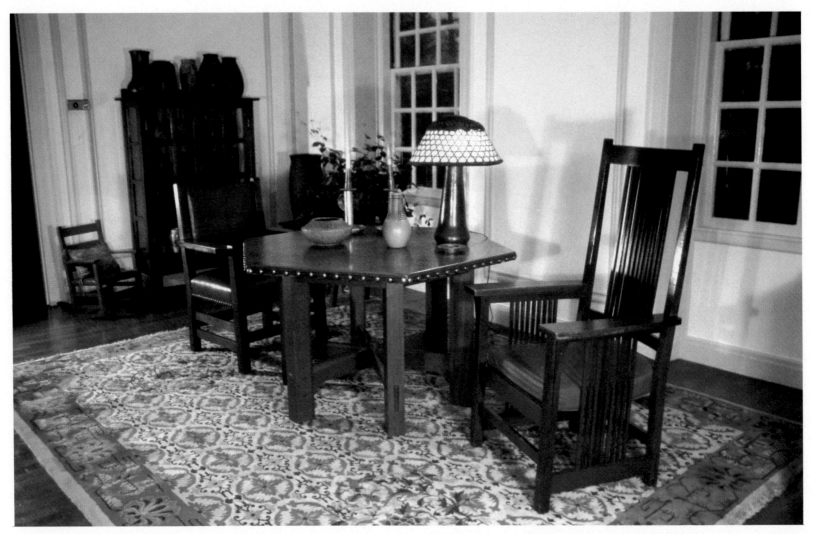

Living room: a leather-topped six-sided table with Stickley armchairs and patterned Chinese carpet.

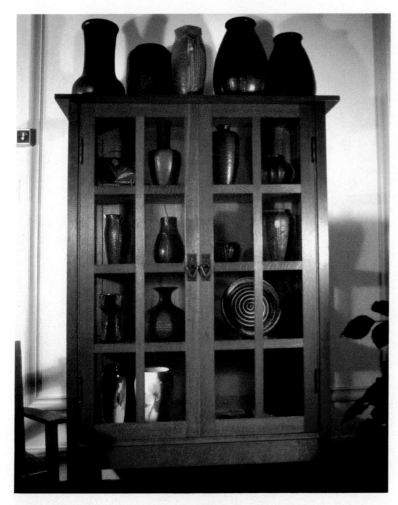

The Mission china cabinet is filled with examples of art pottery.

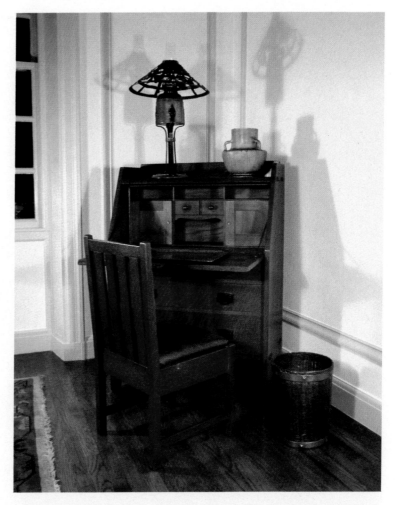

Gustav Stickley drop-front desk with Stickley chair, and wastebasket with Dick van Erp's hammered copper band. A turquoise-colored Tiffany pottery vase, circa 1910, is beside an unusual Gustav Stickley oil lamp.

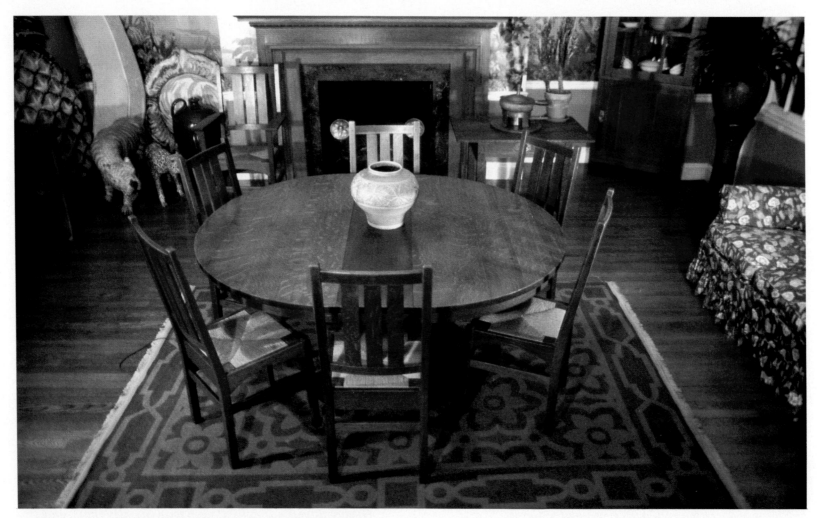

The bright and colorful dining room has a Mission focal point with its table and dining room chairs. Fruit, cut-out flat sculpture, and carved animals join with art pottery and hammered copper to create an eclectic and lively interior. The wallpaper is a fifty-year-old hand-blocked paper in a floral design.

The Jordan-Volpe Gallery

The Jordan-Volpe Gallery in the Soho district of New York City is totally devoted to the finest quality objects of the American Arts and Crafts period. The resurgence of interest in the Arts and Crafts movement, first marked by the 1972 Princeton exhibition, had led two serious collectors, Vance Jordan and Todd Volpe, to amass a large collection. With the opening of their gallery in 1976, they became dealers and, in a sense, educators.

Their gallery is unique in that they maintain comprehensive room settings and *vignettes* of period furnishings, including accessories of all types—metalwork, Tiffany lamps, pottery, and period art. In the fall of 1978, they sponsored a landmark symposium with the Victorian Society of America, focusing on specific aspects of the period. A Fulper pottery exhibition was organized in 1979 and toured various museums.

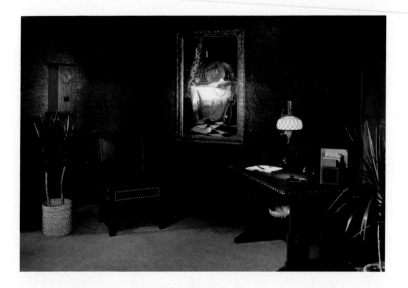

Armchair by Gustav Stickley (top right); trestle table by L. & J. G. Stickley, circa 1905; lamp by Louis Comfort Tiffany, circa 1905; ceramic bowl by Fulper pottery, circa 1915; still life oil painting, dated 1878 by Frank Russell Green; mantel clock by L. & J. G. Stickley, circa 1908; copper inkwell, bowl, and books by the Roycroft Shops, circa 1905; and period leather-tooled bookends.

Hall bench by L. & J. G. Stickley (bottom right); Tiffany pomegranate shade with Grueby pottery-base lamp; L. & J. G. Stickley tall case clock; oil painting by Charles H. Davis, entitled "Evening II"; and a large Fulper vase.

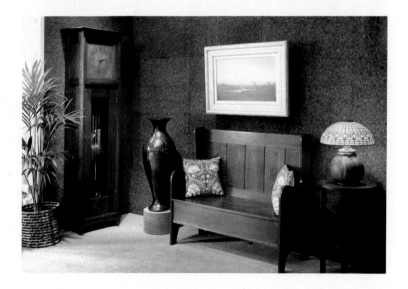

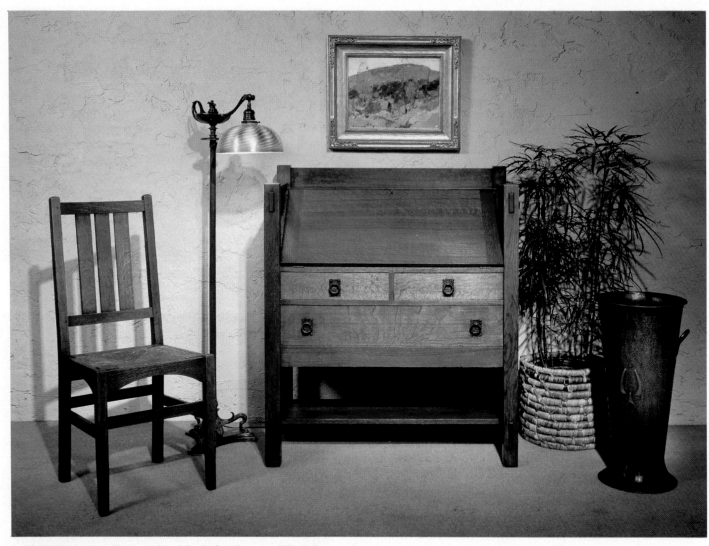

*Side chair by Gustav Stickley's Craftsman Workshops, desk
by Lifetime Craftsmen, floor lamp by Tiffany Studios;
landscape by Chauncey Ryder and copper umbrella stand by
Benedict Studios.*

Building
Mission Furniture

"Properties of the original wood, and thus wood, will probably remain a deeply human material of great richness, with potential that has been nowhere near fully exploited."

Alvar Aalto
extract from the article,
"Wood as a Building Material,"
Arkkitehti, *1956*

Wood, the most aesthetically pleasing of all natural materials, is the basic ingredient for Mission-style furniture. In its original era, Mission furniture was primarily crafted from quarter-sawn oak, which is oak sawn from a log divided into quarters at its radial center. Each quarter in its full length is then sawn into boards, with the board cuts nearly parallel to the lines of growth radiating from the center of the log. This produces a striped effect, exposing the tree's rays as lines. Boards made in this manner seldom warp or twist, but few lumber mills still saw by this method because of the great expense in time and waste. Instead they slice the boards without quartering the log first; this is called plain-sawing. Also, because of an overall oak shortage, oak trees are harvested much younger than they were at the beginning of the century and consequently, today, they have fewer lines in the figure of the grain.

It is difficult to find quarter-sawn oak today, but if it is at all possible, by all means buy it! Its superb quality and durability will make an appreciable difference.*

Gustav Stickley reproduced measured drawings and how-to instructions together with lumber mill listings for a number of pieces of furniture, both large and small. He explained early on that *The Craftsman* was founded with the intention of making it a magazine devoted to the encouragement of handicrafts because he believed in the immense influence for good in the development of character that is exerted merely by learning to use the hands. He strongly felt that the most powerful stimulus to well-defined thought processes was creative manual labor.

Thus, with the publishing of these measured drawings along with the instructions for many authentic details which will help give the completed piece not only an individual crafted appearance, but authentic period finishing as well, we are carrying on a tradition and an ideal promulgated by Stickley and *The Craftsman*.

**Note*: For more information on where to find quarter-sawn oak and other types of hard-to-find wood, see *Fine Woodworking Magazine*, which publishes an annual listing. Reading through the advertisements in any issue is another help. Write to *Fine Woodworking*, the Taunton Press, Inc., P.O. Box 355, Newton, CT 06470. A single issue is $2.50 postpaid.

HOW TO BEND WOOD

The pieces of wood should be cut close to size with only enough material left on them for trimming after the bending has been done. The wood used for bending should be good, clean, "live" lumber. Lumber dried on the stump will not bend.

First, a box must be made in which to steam the pieces of wood to be bent. A design of a steaming box is shown in the illustration. Such a box is made by nailing four boards together into a square or rectangular form, the boards having a length sufficient to take in the length of the furniture parts to be bent. Both ends of the finished box are squared up and closed with a board cut to the size, using felt in the joint to make it as tight as possible. These ends are nailed on, but it is best to hold them with a bar of metal set against each one. Nailing the ends a few times would spoil the box for further use in steaming.

A teakettle will serve the purpose of a steam generator. A hose is attached to the spout of the teakettle, as shown in the illustration, and to the steaming box in a like manner. The steaming box should be provided with a short piece of pipe turned into a hole bored into one of the sides used for the top, on which to attach the hose. A small hole should be bored into one end of the steaming box, and this end should be a little lower than the other end. The hole will permit the condensation to escape.

Steam should not escape from the box when a load of wood is being softened. Steam which escapes from the box in the form of vapor has done no work whatsoever. Therefore, in steaming pieces in the box, never force steam through so hard that the steam escapes around the heads of the box or through any other joints. The steam should be supplied to the box just as fast as it condenses, and no faster. When the pieces are placed in the box, they should be so arranged that the steam can readily surround all sides of each.

The curve or bend of the piece to be made must be marked out on a wide board or on the floor. Nail down several blocks of wood or pieces cut out like brackets on the board or floor against the drawing, as shown in the illustration. The wood is sprung between these blocks or forms after it has been softened by the steam. When taking the steamed pieces from the box, do not lose any time in securing them to the forms. Do not take out more than one piece at a time because it must be bent to the forms *immediately*.

The time of steaming will vary with the size of the pieces of wood. Small strips may be steamed in 15 or 20 minutes, while large ones may require several hours to become soft enough to bend. The pieces must be left in the forms until they are completely and thoroughly dry.

STEAMING BOX

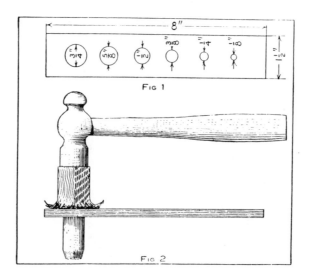

HOSE ATTACHED TO TEAKETTLE

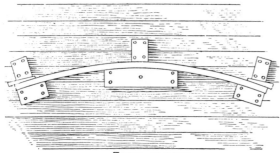

FORM BLOCKS

HOW TO MAKE A DOWEL-CUTTING TOOL

Find a piece of steel, about ¼-inch thick, 1¾-inch wide and 8-inches long. Drill various-sized holes through the steel as shown in Figure 1, leaving the edge of each hole as sharp as the drill will make them.

Cut off a block of wood the length necessary for the dowels and split it up into pieces, about the size for the particular dowel to be used.

Lay the steel on something flat, over a hole of some kind; then start one of the pieces of wood in the proper size hole for the dowel and drive it through with a hammer, as shown in Figure 2. The sharp edges on the steel will cut the dowel as smooth and round as if it were turned in a lathe.

One can buy hardwood dowels of all sizes up to approximately 36 inches in length, from a neighborhood hardware store or lumber yard.

CUTTING TENONS WITH A HAND-SAW

With the use of this tool, tenons may be entirely cut with a saw, discarding the use of a chisel and mallet. The device consists of a convenient length of straight board—A, Figure 1—wide enough to cover the widest piece to be tenoned. A piece of board, B, is fastened to A with brads or small screws. This board should have a thickness equal to the piece to be cut from the side of the tenon.

The piece C is fastened to A and B with small cleats at their upper ends. The space between B and C should be wide enough for the blade of a saw to run through easily, and also long enough to take in the widest part of the saw blade.

The tool and piece to be tenoned are placed in a vise as shown in Figure 2. The width of the piece removed for the tenon may be varied by putting in pieces of cardboard between the work, E, and the piece A, Figure 1.

NOTE: A tenon is the projecting part of a two-piece wood joint. It is inserted in a hole, called a mortise, in the other part of that joint.

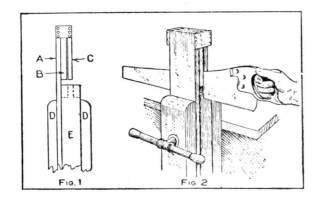

A TOOL FOR MAKING MORTISES

Take a block of wood, A, the exact thickness of the piece B to be mortised, and, using an auger, bore a hole the same size as the width of the mortise to be made and exactly parallel to the sides of the block. This can best be done on a drill press. If none is available, and if you're boring a hole by hand, make sure that the hole is as round as possible.

Then nail a cleat, C, on the side of the block, A, and let it extend down on piece B. Use a clamp to hold the block in place while boring out the mortise. By changing the position of the block and boring a number of holes, any length of mortise can be made. The holes should then be squared up with a chisel.

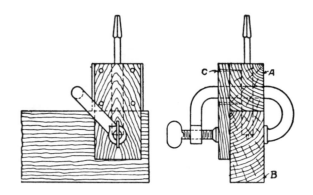

MAKING SCREWS HOLD IN THE
END GRAIN OF WOOD

It is often necessary to fasten one piece of wood to the end of another by means of screws. Wood being a fibrous material, it can be readily understood that when a screw having sharp threads is put in the end grain parallel to these fibers the threads cut them in such a way that, when an extra strain is put on the parts, the screw pulls out, bringing with it the severed fibers. The accompanying illustration shows how this may be overcome, and at the same time, the screw can be made to hold more firmly.

A hole is bored and a dowel, preferably of hardwood, glued in it, with the grain at right angles to that of the piece.

The size of the dowel, and its location, can be determined by the diameter and the length of the screw. The dowel need not extend all the way through the piece, but should be put in from the surface where the grain of the dowel will be least objectionable. Applying soap to the threads of the screws will eliminate extra labor.

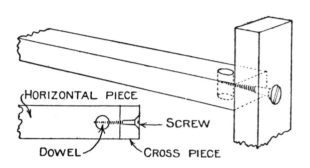

ARMCHAIR

Materials:

- 2 rear posts, 1½″ × 1½″ × 38″
- 2 front posts, 1½″ × 1½″ × 26½″
- 10 rails, ⅞″ × 2″ × 19½″
- 3 slats, ½″ × 2″ × 12½″
- 2 arms, ⅞″ × 4½″ × 20½″
- 2 brackets, ⅞″ × 2¼″ × 2½″
- 2 cleats, ⅜″ × 1″ × 19″
- 4 slats, ⅜″ × 2″ × 19″

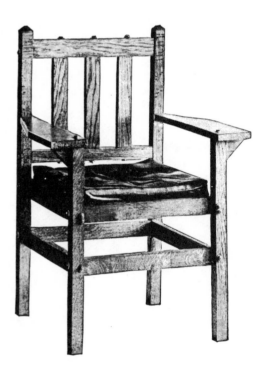

Instructions:

Prepare the posts first, by cutting them to the lengths shown in the measured drawing. In the illustration the front posts have their tops cut off square and the arms fastened to them with screws. A better way from a mechanical point of view would be to shoulder the top ends on the four sides, cut through-mortises in the arms, and insert these tenoned posts into these mortises, pinning the arm to the post by means of small dowels on the edge of the arm and through the tenon.

The brackets under the arms are to be fastened to the posts and arms by means of concealed dowels and glue.

All the rails should be tenoned into the posts thoroughly even if screw fastenings are used.

The shape of the arms is indicated in the drawing. They are fastened to the rear posts by means of dowels and glue.

The slats, or verticals, of the back should not have their ends tenoned but should have the mortises in the rails cut sufficiently large to "let in" the whole end of each. Any unevenness in the lengths of the respective slats will not affect the fitting of the joints by this method.

The tops of the rear posts are cut to angles of 45 degrees, beginning the slope at lines marked ½ inch from the tops.

The bottom is made up of 2-inch slats fitted between the front and back rails and fastened to cleats. These cleats are fastened to the insides of the front and back rails just before the slats are assembled. It is easiest to put the cleats on when the chair is together. Keep them low enough on the rails so that the top surfaces of the slats rest somewhat below the top edges of the rails.

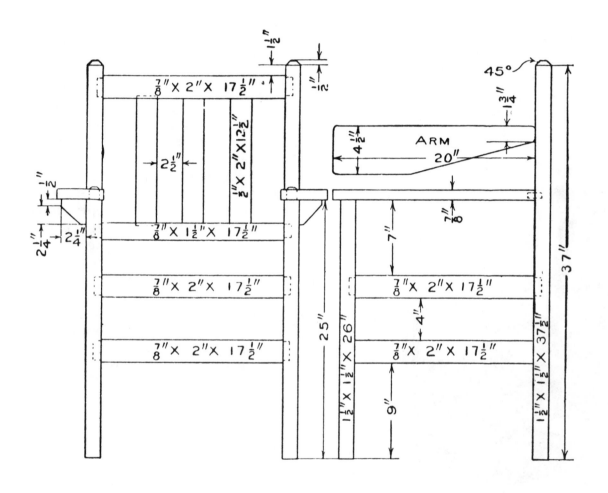

CURVED-BACK ARMCHAIR

Materials:

front posts, 2 pieces, 1⅝″ × 2¼″ × 26″
back posts, 2 pieces, 1⅝″ × 8″ × 45″
front horizontals, 2 pieces, ¾″ × 3½″ × 21½″
rear horizontals, 4 pieces, ¾″ × 3½″ × 19¼″
side horizontals, 4 pieces, ¾″ × 3½″ × 19½″
back slats, 2 pieces, 5/16″ × 3½″ × 19½″
arms, 2 pieces, 1⅛″ × 4″ × 24″
seat slats, 5 pieces, ½″ × 2¼″ × 20″

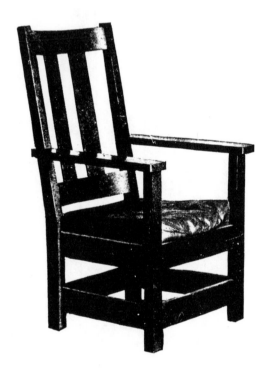

Instructions:

With the exception of the back legs, the Materials listing gives the exact thicknesses and widths needed. To the length, however, enough has been added to allow squaring up the ends.

Begin work by squaring up the ends of the front posts and shaping the rear ones. Bevel the ends of the tops and bottoms slightly so they will not splinter. Next lay out the mortises and tenons.

The curved horizontals for the back should now be prepared and steamed as described on page 44. The curved form to which the steamed piece is to be clamped to give shape should be curved slightly more than necessary because the piece, when released, will end to straighten a little. The arms of the chair may be shaped while these pieces are drying on the forms. The rails of the front and back may be tenoned, too.

It should be noted that the front of the chair is wider than the back. This will necessitate care in mortising and tenoning the side rails so the shoulders will fit well. The bevel square will be needed in laying out the shoulders of the tenons.

The seat is a loose leather cushion resting on slats. These seat slats may be fastened to cleats, which have been previously fastened to the inside of the front and back seat rails, or they may be "let in" to these rails by grooving their inner surfaces before the rails have been put into place.

Assemble the back, then the front. When the glue has hardened so the clamps may be removed, put in the side rails or horizontals. The arms are then fastened to the posts with dowels and glue.

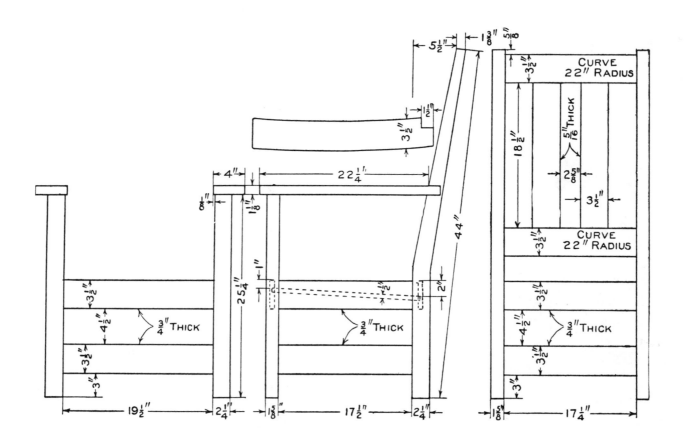

SIDE CHAIR

Materials:

4 rails, ⅞" × 2" × 17½"
4 rails, ¾" × 2" × 17½"
2 front posts, 1½" × 1½" × 19"
2 rear posts, 1½" × 1½" × 37½"
1 back, ¾" × 9¾" × 17½"
2 cleats, ⅜" × 1" × 16"
4 slats, ⅜" × 2" × 16½"

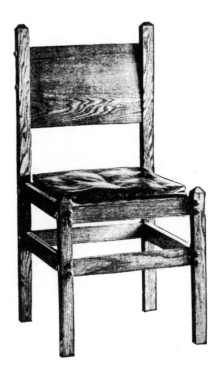

Instructions:

Begin work by cutting the posts to the lengths indicated in the measured drawing. The lower ends should be beveled slightly to prevent splintering. The top ends are cut to an angle of 45 degrees, the slope beginning ½ inch below the top.

Lay out and cut the mortises. To do this, lay off the measurements on one of the posts, then place all four posts side by side on the bench, with the face marks up. Even the ends with a T-square and then carry the measurements just made across all of them, using the T-square. The rails ought to be shouldered on all four sides. A good thickness for the tenons is ⅜ inch. The width may be 1¼ inches, and the length 1 inch.

Place the rails side by side on the bench with the joint-edges up and the ends evened. Measure off the desired length on one of them and carry the lines across all of them to indicate the location of the shoulder lines. Separate the pieces and square these lines entirely around all of the sides of each piece. With the tenon saw, rip and cross-cut to these lines, sawing both with and across the grain.

The back is set on a slant to add comfort. Thoroughly clean all the parts and assemble them with glue. Put the back of the chair together first, then the front. After these have dried, put the side rails in place.

Cut and fit the two cleats—one to the front rail and one to the rear rail. Keep hem even with the lower edge of the rail so as to form a slight recess at the top when the slats are in place. This is to keep the cushion from sliding off. The slats need not be "let into" the cleats but merely fastened to their top edges.

In the chair shown, the joints are reinforced by the addition of screws. If the glue is good and the joints well-fitted, these are not necessary.

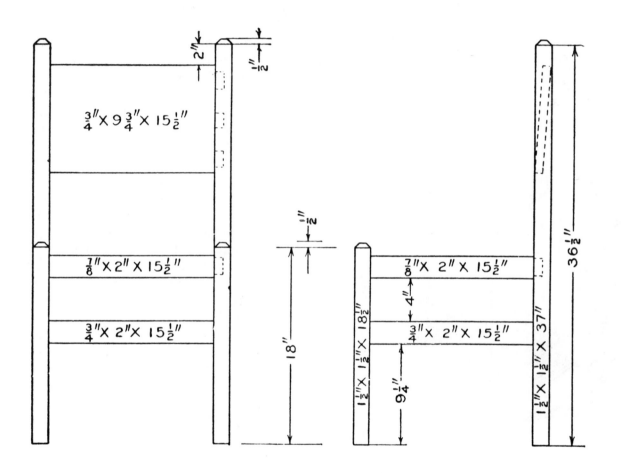

$\frac{3}{4}''\times 9\frac{3}{4}''\times 15\frac{1}{2}''$

$2''$

$\frac{1}{2}''$

$\frac{7}{8}''\times 2''\times 15\frac{1}{2}''$

$\frac{3}{4}''\times 2''\times 15\frac{1}{2}''$

$\frac{1}{2}''$

$18''$

$\frac{7}{8}''\times 2''\times 15\frac{1}{2}''$

$4''$

$\frac{3}{4}''\times 2''\times 15\frac{1}{2}''$

$9\frac{1}{4}''$

$1\frac{1}{2}''\times 1\frac{1}{2}''\times 18\frac{1}{2}''$

$1\frac{1}{2}''\times 1\frac{1}{2}''\times 37''$

$36\frac{1}{2}''$

ROCKING CHAIR

Materials:

2 front posts, 1⅝″ × 2¼″ × 22½″
2 back posts, 1⅝″ × 11″ × 40″
1 front horizontal, ¾″ × 3½″ × 22″
3 back horizontals, ¾″ × 3½″ × 20″
2 side horizontals, ¾″ × 3½″ × 20″
2 back slats, 5/16″ × 3½″ × 20″
2 arms, 1″ × 4½″ × 25″
2 rockers, 1¼″ × 2¼″ × 33″
5 bottom slats, ¾″ × 2¼″ × 19½″

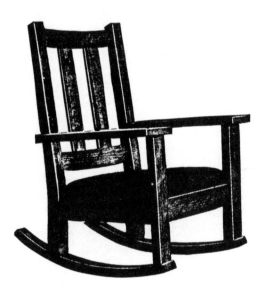

Instructions:

Begin work by cutting the posts and the rockers. The rockers must be steamed and bent. The front posts should have the top end squared for fitting under the arm. Or the top end may be shouldered and have a tenon which will fit through a mortise in the arm. It should be fastened with dowels through the inside of the arm and into the tenon. Both the front and the back posts must be cut on the bottom to fit the curve of the rocker. They are to have tenons to fit the mortises in the rockers. The top of the back posts can be beveled to prevent slivering. The arm should be cut according to the measured drawing and fastened through the top with dowels and glue if a tenon and mortise is not used. Then cut the mortises in the posts for the rail tenons.

Next prepare the parts for the back, along with the rails. Steam and bend the curved parts of the back; this technique is described under the heading "How to Bend Wood." The forms for the curved parts should have a surface radius of 22 inches. Cut the tenons for the rails and the curved back parts. The back slats can be let into the curved back parts. The chair is 2 inches wider in the front than in the back. The tenons of the side rails must enter the mortises in the posts at an angle. It will be easier to make the tenon at an angle and bevel off its shoulder than to cut the mortise at an angle.

The slats for the bottom are made long enough so that

their ends may be let into the front and back rails. Or, they may be made to fit inside the rails and fastened on front and back cleats.

Assemble the back and then the two sides, which include the front and back post with arm, rocker and rail between. Then attach both sides to the back and to the front and back rails. Clean off the excess glue, sandpaper and stain as desired. A leather cushion can be made stuffed with 4-inch foam or purchased from an upholsterer.

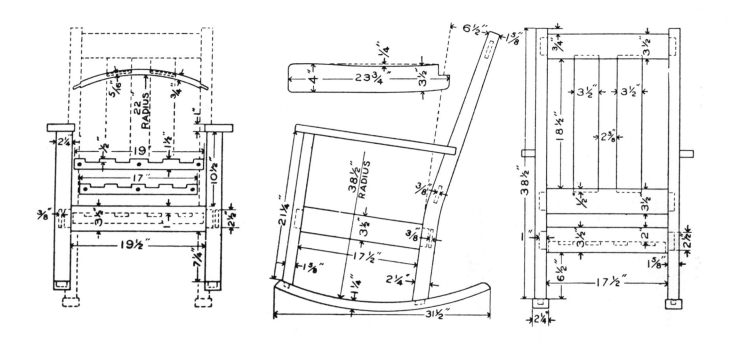

MORRIS CHAIR

Materials:

4 posts, 1¾″ × 3″ × 36″
2 front and back rails, ⅞″ × 5½″ × 24″
2 side rails, ⅞″ × 5½″ × 28″
2 arm pieces, ⅞″ × 5½″ × 37″
7 slats, ⅜″ × 2″ × 24″
2 cleats, 1″ × 1″ × 22½″
2 back stiles, 1″ × 2½″ × 24½″
2 back rails, 1″ × 2″ × 17″
3 back slats, ⅜″ × 1½″ × 19″
1 back support, ¾″ × ¾″ × 24″
2 support rests, 1″ × 1½″ × 8½″
2 dowels, ½″ diameter, 6″ long

Instructions:

First make and put together the sides of the chair. While the glue is drying, make and assemble the back. Place the front and back rails next, and fasten the cleats and bottom slats. With the adjustment of the back, the chair is ready for the finish.

The posts are tenoned on the upper ends. These tenons will project 3/16 inch above the arm and should be slightly beveled. The lower ends of the posts, and all other projecting ends, should be beveled to avoid splintering. All sharp corners, as on the arms, should be sandpapered just enough to take away their sharpness.

So that the chair will be properly inclined, the rear posts must be cut 1 inch shorter than the forward ones. To get the correct slant on the bottoms of these posts, lay a straightedge so that its edge touches the bottom of the front post at its front surface, but keep it 1 inch above the bottom of the rear post. Mark with a pencil along the straightedge across both posts.

At the rear ends of the arms are the notched pieces that allow the back to be adjusted to different angles. These pieces may be fastened in place by means of either roundhead screws from above or flathead screws from underneath the arms. The notches are to be cut ¾-inch deep. If more than three adjustments are desired, the arms must be made longer.

The dimensions for the tenons on all the larger pieces will be found on the measured drawing. For the back,

the tenons of the crosspieces (the rails) should be ⅜ × 1¼-inches. For the slats, the easiest way is not to tenon them but to "let in" the whole end, making the mortises in the rails ⅜ × 1½-inches.

Cushions may be purchased from an upholsterer. The bottom cushion should be the full size of the chair. If the front and back rails extend a little above the slats it will stay in place. The back cushion will settle down a little and therefore may be made nearly the full length from the slats to the top of the back.

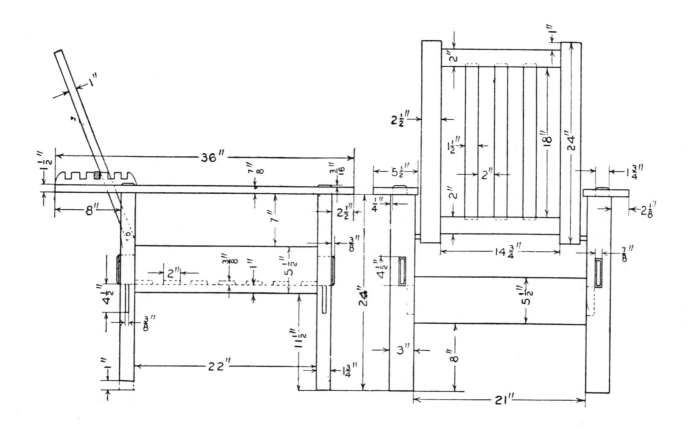

COUCH

Materials:

2 posts, 3" square × 17"
2 posts, 3" square × 26"
2 rails, ⅞" × 8" × 82"
1 rail, ⅞" × 8" × 25"
1 end, ⅞" × 18" × 25"
1 piece, ⅞" × 9" × 24½"

Instructions:

The last piece on the Materials listing, when sawed diagonally, makes the two slanting side pieces at the head of the couch. The corner braces are made from two pieces of straight-grained oak, 2 × 4½ × 4½ inches, sawed on the diagonal, and cut as shown in the enlarged plan section of the measured drawing, to make the four pieces.

First, be sure the legs are perfectly square—the two short ones and the two long ones of equal length respectively. Either bevel or round the upper ends as desired; chisel and plane the taper on the lower ends. Lay out and cut all the tenons on the rails—1 inch is the amount allowed at each end in the stock dimensions given. Arrange the posts and rails in the positions they are to occupy in the finished couch. Number each tenon and the place its corresponding mortise is to be cut in the post. Mark each mortise directly from the tenon which is to fit into it, taking care to have all the rails an equal distance from the floor. Bore and chisel out all mortises and see that all the rails fit perfectly, before proceeding with the work.

The next step will be to fit in the slanting side-pieces at the head of the couch. These must be let into the long posts ½ inch and held also by a dowel in the side rail. In order to get these pieces into place, the mortise in the long post must be made ½-inch longer than the tenon on the sloping side piece so the tenon may be first pushed into the mortise and then the side clamped down on the rail over the dowel. The whole couch should fit together perfectly before gluing any of the parts.

Glue the end parts together first. Then glue in place the side rails and slanting head pieces. Screw in place the corner braces. Be sure, when making these barces, to have the grain running diagonally across the corner, or the brace will be weak. Also, be sure the sides are square with the ends; this may be determined by measuring the diagonals to find if they are equal.

If it is decided to use frames for the cushions, then the following materials will be necessary:

2 pieces ⅞" × 2" × 56"
2 pieces, ⅞" × 2" × 25"
4 pieces, ⅞" × 2" × 25"

The materials may be of pine or poplar. These pieces are made into two frames as shown in the drawing and held together with long screws or nails. Glue and screw short blocks on the inside of the couch rails for holding the two frames in place. Tack pieces of burlap across the frame and cover with mattress ticking. This will give a strong, springy rest for the cushions.

(continued on page 60)

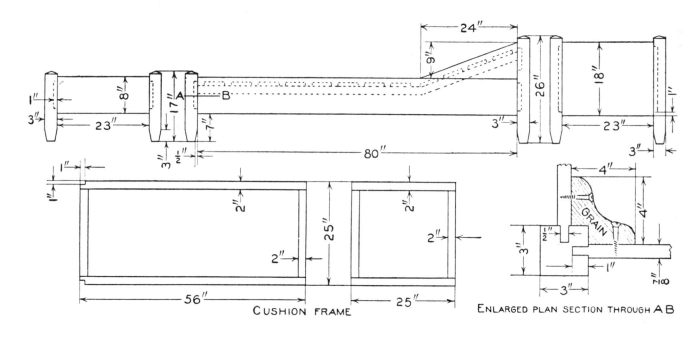

24″

9″

8″

1″

3″

23″

17″

A

B

7″

3″

½″

26″

18″

1″

3″

23″

3″

80″

1″

1″

2″

2″

25″

2″

2″

2″

56″

25″

CUSHION FRAME

4″

4″

½″

GRAIN

3″

1″

3″

⅞″

ENLARGED PLAN SECTION THROUGH A B

Should slats be used instead of frames for holding the cushions, then the following list of materials should be substituted:

2 cleats, ⅞″ × 2″ × 56″
2 cleats, ⅞″ × 2″ × 25″
12 slats, ¾″ × 5″ × 25″

The materials listed may be of soft wood the same as for the frame. The cleats are fastened to the inside of the rails of the couch with screws so the top edge will be 2 inches lower than the top edge of the rails. The slats are spaced evenly on these cleats.

After the glue is set, remove the clamps and scrape off any glue that may be on the wood.

UMBRELLA STAND

Materials:

4 posts, 1½″ × 1½″ × 28″
4 top rails, ⅞″ × 2″ × 10″
4 lower rails, ⅞″ × 3″ × 10″
4 slats, ⅜″ × 3″ × 20″
1 bottom, ⅞″ × 10″ × 10″

Instructions:

Square up the posts and bevel the tops. Place them side by side on a flat surface with the ends square, and lay out the mortises with a T-square on all four pieces at the same time. This will insure your getting them straight.

Now lay out the tenons on the rails in the same manner and cut them to fit the mortises in the posts. Mortises should also be cut in the rails for the ends of the side slats. Try all the joints and make sure they fit tightly. Glue two sides of the stand together and let dry.

The bottom board can now be fitted in place. It should have a hole cut in it for the drip pan. This pan should be about 6 or 7 inches in diameter. The bottom board can be fastened to cleats screwed to the rails.

When the stand is complete, scrape all glue from around the joints and go over with fine sandpaper, removing all rough spots.

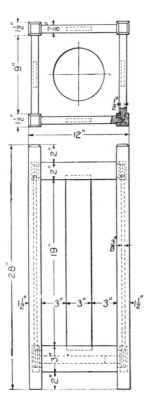

SETTLE

Materials:

 3 rails, $1'' \times 4'' \times 52\frac{1}{4}''$
 4 end rails, $1'' \times 4'' \times 24\frac{1}{4}''$
 4 posts, $2\frac{1}{4}''$ square $\times 34\frac{1}{2}''$
13 slats, $\frac{7}{8}'' \times 5'' \times 21\frac{1}{4}''$
 2 cleats, $1''$ square $\times 51''$

Instructions:

All the rails are mortised into the posts for a depth of $\frac{5}{8}$-inch; also, the slats are mortised $\frac{5}{8}$-inch into the rails. The list of materials gives the exact dimensions for the rails and slats because they will not need to be squared before entering the mortises. The posts have $\frac{1}{2}$ inch extra added for shaping the top ends.

The joints are all put together with glue. Nails can be driven into the posts intersecting the tenons of the rails on the inside since they will not show and will help to make the settle more solid.

If you would like to make the cushions in your own workshop, the following instructions have been adapted from the original directions:

If the cushions are to be made without springs, 15 slats must be provided in the list of materials, $\frac{1}{2}$-inch thick, 2 inches wide and 24 inches long, to be placed on the cleats fastened to the inside of each bottom rail. The cleats are fastened on the insides of the front and back rails with screws. The location (or height) of these cleats will depend upon the kind of cushions used. The parts necessary to make cushions with springs are as follows:

 4 pieces, $1'' \times 2\frac{1}{2}'' \times 26''$
 8 pieces, $1'' \times 2\frac{1}{2}'' \times 24''$
 4 pieces, $1'' \times 2\frac{1}{2}'' \times 22''$
32 $8''$ springs
 2 pieces leather, $29'' \times 31''$

A rectangular frame is made from two 26-inch and two 22-inch pieces, and across the bottom are mortised and set in four 24-inch pieces to form slats on which to set the springs. The tops of the springs are tied or anchored with stout cords which are run in both directions and fastened to the inside of the pieces forming the frame. These should be tied in such a manner as to hold each spring so it cannot slip over and come into contact with another spring. Or use 4-inch-thick foam, cut to fit the inside of the open box.

The leather is drawn over the springs or foam and tacked to the outside of the open box frame. When complete, the cushions are set in loose on the cleats, which should be placed about 1 inch from the top of the rails.

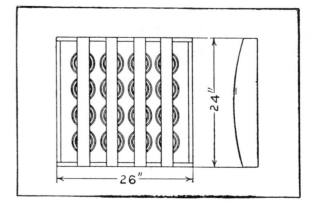

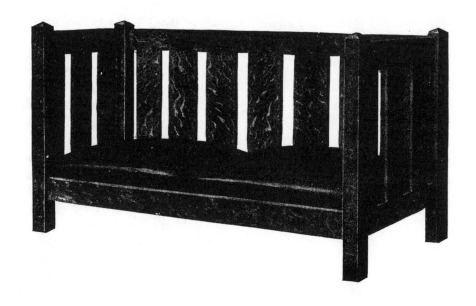

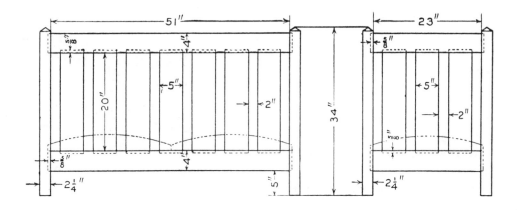

LIBRARY TABLE

Materials:

4 legs, 2" × 2" × 30¼"
1 top, 1⅛" × 30" × 42"
2 end pieces, ¾" × 17⅛" × 29"
2 top rails, ⅞" × 2" × 37"
2 top rails, ⅞" × 2" × 25½"
1 lower brace, ¾" × 2" × 32"
4 shelves, ¾" × 7" × 29"
8 slats, ¼" × 1⅛" × 17⅛"
2 drawer fronts, ¾" × 5¾" × 25"
4 drawer sides (softwood), ⅜" × 3¾" × 14"
2 drawer ends (softwood), ⅜" × 3⅜" × 24¼"
2 drawer bottoms (softwood), ⅜" × 13¼" × 24¼"
2 drawer supports (softwood), ¾" × 2" × 23½"
2 drawer supports (softwood), ¾" × 2" × 25"

Instructions:

Bevel the tops of the legs and square them up, laying out the mortises for the shelves as shown in section BB on the measured drawing. Take care to get the legs mortised in pairs and cut the same height. This is best done by placing the four legs side by side with the ends square, and then laying out the mortises across all four at once with a T-square.

The table top is made of several boards which are doweled and glued together. Be careful to get the best side of the board up and have the joints fit tightly. The corners should be cut out for the posts as shown. The posts are fastened to the board with screws, which can be countersunk and plugged. The top rails are also fastened to the top board with screws.

For the end pieces, two or more boards will have to be glued together. The end piece top corners have to be cut to fit around the top rails. Cleats can be used to fasten them to the top board. The shelves also have their corners cut to fit into the mortises in the posts. Screws hold them to the end boards.

When all parts fit square and tightly, they can be glued and screwed together. The table is then complete except for the slats and slanting drawers.

The slats can be fastened with nails, then the heads covered with fancy nails. In order to place the drawer supports, screw them to the end boards. A bottom brace should be fastened under the lower shelves to help steady the table. The two drawers are constructed as shown on the detail sketch in the measured drawing. No handles are needed because the lower edge of the front board can be used for pulling them out.

When the table is completed, it should be carefully gone over with fine sandpaper and all rough spots removed. Scrape any excess glue from the joints and apply stain, as desired.

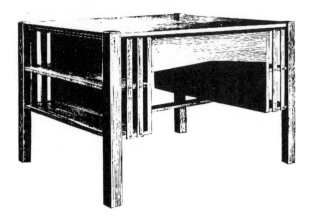

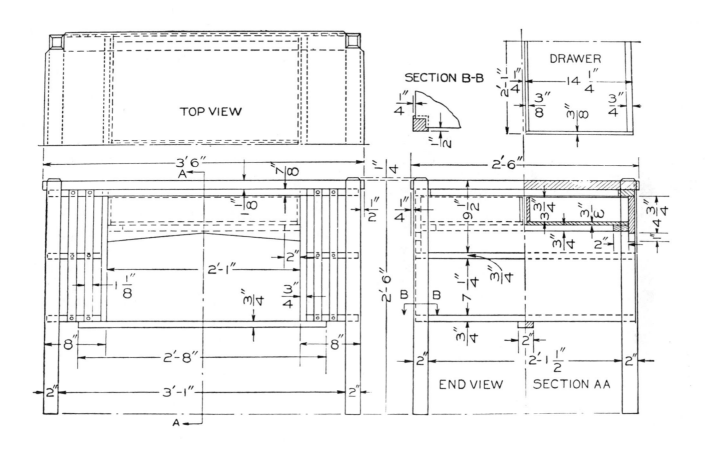

TOP VIEW

SECTION B-B

DRAWER

$14\frac{1}{4}$"

$2'-1\frac{1}{4}$"

$\frac{3}{8}$" $\frac{3}{8}$" $\frac{3}{4}$"

$\frac{1}{4}$"

$\frac{1}{2}$"

$3'6$"

$\frac{7}{8}$

$\frac{1}{4}$"

$2'-6$"

A

$\frac{1}{8}$"

$\frac{1}{2}$"

$\frac{1}{4}$"

$9\frac{1}{2}$"

$\frac{3}{4}$"

$\frac{3}{8}$"

$4\frac{3}{4}$"

$2'-1$"

2"

2"

$1\frac{1}{8}$"

$\frac{3}{4}$"

$\frac{3}{4}$"

$7\frac{1}{4}$"

$\frac{3}{4}$"

B B

$\frac{3}{4}$"

8"

8"

$2'-8$"

$\frac{3}{4}$" 2" $2'-1\frac{1}{2}$"

2"

2"

END VIEW

SECTION AA

2"

$3'-1$"

2"

A

MAGAZINE TABLE

Materials:

4 legs, 2″ × 2″ × 29″
4 end slats, ½″ × 2″ × 10″
1 shelf, 1″ × 16″ × 30″
1 top board, 1″ × 18″ × 36″

Instructions:

The four legs are finished on all sides and beveled at the bottom to prevent the corners from splitting. The mortises for the shelf should be cut 9 inches from the top of each leg, as shown in the measured drawing. Care should be taken to make these a perfect fit.

The shelf should be finished on the top side and the four edges, and the corners cut out to fit the mortises in the table legs. An enlarged view of this joint is shown in the measured drawing.

The top board may have to be made of two 9-inch boards, dovetailed and glued together. It should be finished on the top side and the edges. The edges can be beveled, if desired. The board is fastened to the legs by means of screws.

The top board and the shelf should be mortised at each end for the ½ × 2-inch slats. These slats should be finished on all sides.

The table is now ready to be assembled and glued together. After the glue is dry, carefully go over the entire table with fine sandpaper to remove all surplus glue and rough spots.

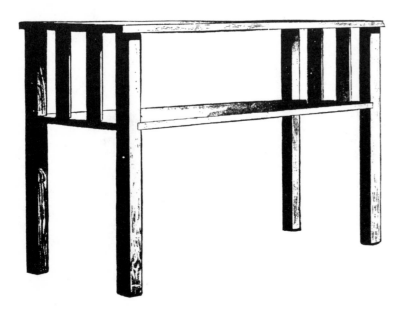

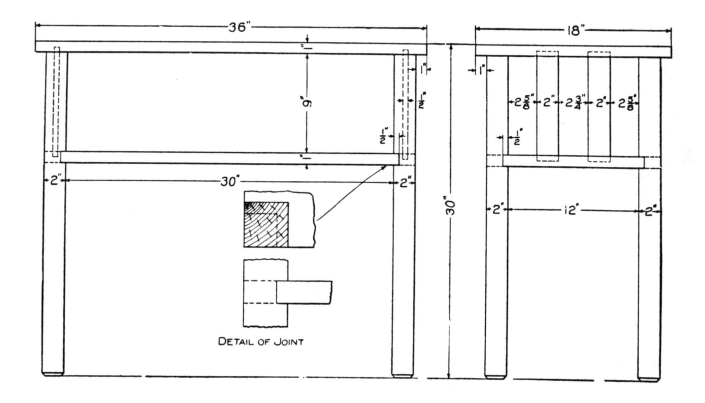

DETAIL OF JOINT

MAGAZINE STAND

Materials:

1 top, ⅞" × 15½" × 16½"
1 shelf, ⅞" × 11½" × 12½"
1 shelf, ⅞" × 12½" × 14¾"
1 shelf, ⅞" × 13½" × 16½"
2 sides, ⅞" × 14½" × 33½"
2 braces, ⅞" × 3¼" × 17"
2 braces, ⅞" × 2½" × 11½"
6 braces, ⅞" × 2" × 2"

Instructions:

Notice from the line drawing that all pieces, except the top board, have angular joining edges. These beveled edges are to be measured from a full-sized line drawing of the front view.

Begin work on the sides first. Set a bevel square by adjusting its angle to the top or bottom of the side on the full-sized line drawing. Transfer this measurement to the top and bottom ends of the sides and plane to fit. Next lay out the nearly vertical edges on both sides by first marking off 14 inches on the bottom. At the top, mark off 1½ inches from each edge. The connecting points will indicate a full 14 inches at the bottom tapering to 11 inches at the top. Mark the location of the shelves on these edges. Hold both sides together and mark them at the same time to insure that the shelf will be level. The design at the bottom of the sides can be varied to suit one's taste. Or, cut out a pattern from the full-sized line drawing made for the work above and trace in position on the wood.

Make the three shelves next. Bevel the joining edges after measuring the full-sized line drawing for the angle and length of each shelf. The grain on the wood will run with the length of the shelf. The width of the shelf also must be measured from the full-sized line drawing. If the shelves are to be faced with leather, make an allowance for its thickness by making the width of each shelf ½ inch less. The top of the stand is a square piece without angles on the edges, and it measures 15 by 16 inches long.

Now these pieces can be assembled and fastened in a variety of ways. Roundheaded screws may be placed at regular intervals along the sides and into the shelves. Finishing nails may be used and the heads set and covered with putty stained to match the wood, or the heads can be covered by brass upholstery tacks.

The braces should be measured and made from the full-sized line drawing and fitted, but they should not be fastened until the finish has been applied. Scrape off excess glue, sandpaper and finish by staining to a golden oak color. The shelves may be faced with leather and fastened with brass upholstery tacks.

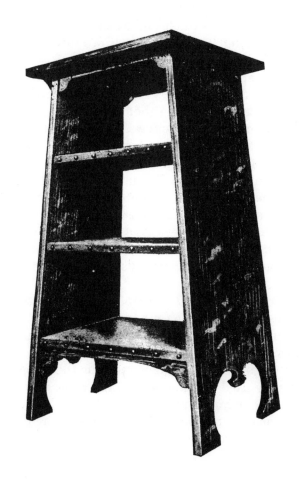

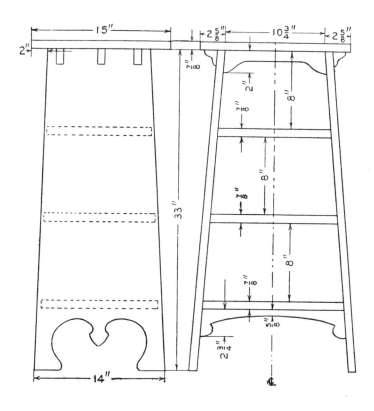

DINING TABLE

2 top pieces, 1″ × 23″ × 46″
2 extra leaves, 1″ × 12″ × 46″
2 rails, ¾″ × 3″ × 44″
4 rails, ¾″ × 3″ × 22″
2 pieces for posts, ¾″ × 8″ × 24″
2 pieces for posts, ¾″ × 6″ × 24″
4 pieces for feet, 3″ × 3″ × 14″
4 pieces for feet, 3″ × 3″ × 5″
4 pieces for feet, 1″ × 4″ × 4″
4 pieces moulding, 1″ × 1″ × 10″
1 rest piece, 1″ × 12″ × 27″
2 brackets, ¾″ × 3″ × 32″
2 pieces for slide, 1¾″ × 3″ × 36″
4 pieces for slide, 1″ × 3″ × 36″
12 pieces for slide, ¾″ × 1½″ × 36″
4 casters, if desired

Instructions:

The feet can be made first, by squaring up one end of each and beveling the other end as shown in the measured drawing. The short pieces are fastened to the long ones by means of long screws and glue. The four square pieces should be nailed to the outer ends and holes bored in them for the casters. Prepare the pieces for the posts, and before nailing them together, fasten the feet to them with long screws. Make sure they are on square or the table will not be level when complete. Now nail and glue the pieces forming the posts and fasten the molding at the bottom. The molding should have mitered corners as shown in the bottom view on the measured drawing. Also, fasten the rest piece to the top of the post, using long screws and glue.

The slides can be made next. The pieces are made and fastened together with screws as shown in the enlarged detail view.

The center piece should be firmly fastened to the post rest with long screws. The screws that fasten into the top board should be inserted from below through counterbord holes as shown.

Miter the rails at the corners and glue them to the top. Blocks can be used on the inside of the rails; this would make a stronger construction. Screw the two brackets to the top, as shown. These will help to support the table when it is extended.

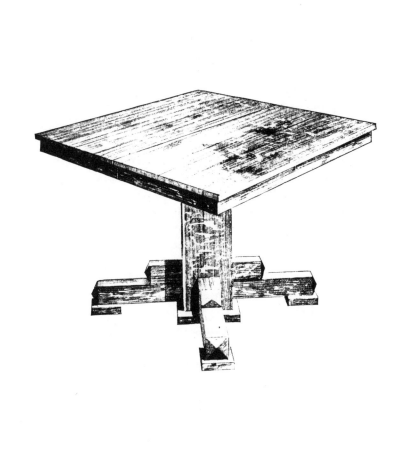

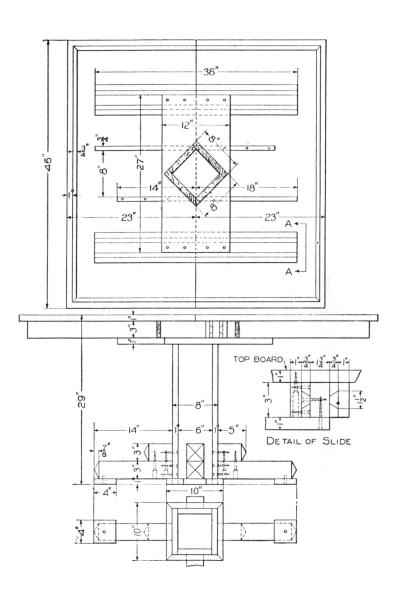

TOP BOARD

DETAIL OF SLIDE

SERVING TABLE

Materials:

2 posts, 2″ × 2″ × 37″
2 posts, 2″ × 2″ × 31″
1 top, 1″ × 21″ × 40″
2 side rails, ¾″ × 3″ × 34½″
4 end rails, ¾″ × 3″ × 15½″
1 back panel, ¾″ × 4″ × 34½″
1 stretcher, 1″ × 5″ × 36½″
1 slat, ½″ × 1½″ × 36″

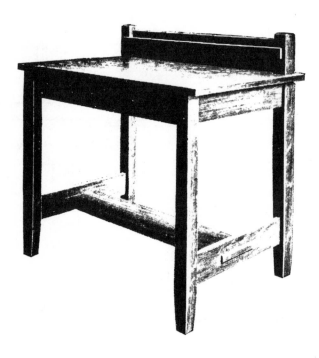

Instructions:

The four posts have been listed 1 inch longer than necessary, to allow for squaring to length. The two back posts should be beveled ¼-inch on top. All of the posts are cut so that they begin to taper 4 inches from the bottom ends. Mortises in the posts and tenons on the rails are laid out and cut, as shown by the dimensions in the measured drawing. These parts are then well glued and put together.

The top is cut to fit around the back posts so that the back edge and the back side of the posts are flush. The back panel is placed in mortises cut in the corners of the back posts. This is done so that the back surface of the panel will be flush with the back edge of the top. A tenon is cut on both ends of the stretcher and made to fit into a mortise on both of the lower end rails.

The slat is fastened with round brass screws on the front of the two back posts, about halfway between the top and the ends of the posts.

The top may be fastened to the rails by one of two methods. One is to use a small wood button mortised in the rails and fastened to the top with screws. About six of these buttons would be sufficient to hold the top in place.

The other method is to bore a hole slanting on the inside of the rails, directing the bit toward the top, which will made a seat (but not cut too deep) for a screw that can be turned right into the top.

Remove any glue from around the joints and smooth the surfaces with fine sandpaper before applying the stain.

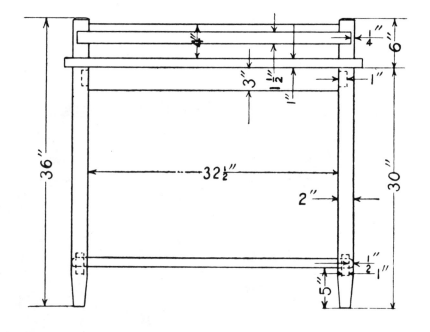

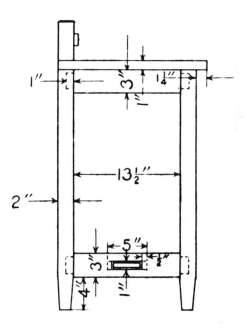

BUFFET

Materials:

2 back posts, 2″ × 2″ × 47¾″
2 front posts, 2″ × 2″ × 45½″
4 rails, 1½″ × 1½″ × 50½″
2 end rails, 1½″ × 1½″ × 18½″
4 end rails, ¾″ × 4″ × 18½″
4 pieces for end panel, ¾″ × 3½″ × 21″
2 panels, ⅜″ × 12″ × 21″
1 top board, ¾″ × 17½″ × 47¼″
1 back board, ¾″ × 11½″ × 47¼″″
1 shelf board, ¾″ × 2″ × 46″
2 brackets, 1″ × 2″ × 7¾″
4 pieces for doors, ¾″ × 4″ × 11″
2 panels, ⅜″ × 11″ × 17½″
1 piece for drawer, ¾″ × 8″ × 22½″
1 piece for drawer, ¾″ × 7½″ × 22½″
1 piece for drawer, ¾″ × 7″ × 22½″
2 pieces (softwood), ½″ × 8″ × 19¼″
2 pieces (softwood), ½″ × 7½″ × 19¼″
2 pieces (softwood), ½″ × 7″ × 19¼″
1 piece (softwood), ½″ × 8″ × 19¼″
1 piece (softwood), ½″ × 7½″ × 19¼″
1 piece (softwood), ½″ × 7″ × 19¼″
1 bottom board (softwood), ¾″ × 17½″ × 47¼″
2 partitions (several pieces), ¾″ × 20″ × 24¾″
2 front pieces, ¾″ × 2″ × 23″
2 back pieces (softwood), ¾″ × 2″ × 23″
2 side pieces (softwood), ¾″ × 2″ × 23″
1 back (several pieces), ⅜″ × 25″ × 46″
1 mirror frame to suit mirror

Instructions:

Start to work on the four posts by squaring them up to the proper length in pairs and beveling the tops as shown in the measured drawing. Clamp all four pieces on a flat surface with the bottom ends even; then lay out the mortises for the rails and panels on all four pieces with a T-square. This will insure making all the mortises the same height. The back posts also have a mortise cut in them at the top for the back board. Lay out the tenons on the ends of the front and back rails in the same manner. Cut them to fit the mortises in the posts; also

(continued on page 76)

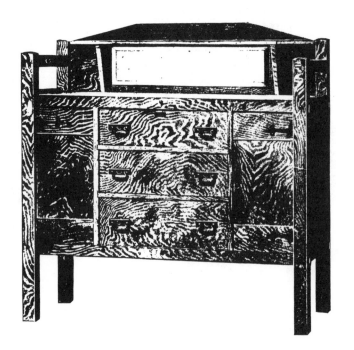

74

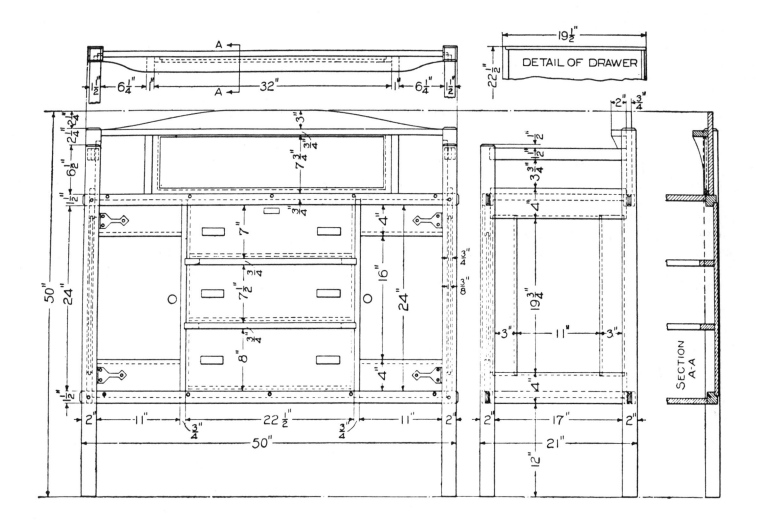

DETAIL OF DRAWER

SECTION A-A

rabbet the back rails for the backing. Cut tenons on the end rails and rabbet them and the side pieces for the panels.

Lay out the top and bottom boards to the proper size and notch the corners to fit around the posts. These boards are fastened to the 1½-inch square rails with dowels and glue. They can then be glued together and set to dry. The top board is of oak with the best side up; the bottom board can be made of pine.

The partitions are made of several boards glued together. Be careful to get an oak board on the outer edge. The drawer slides are set into the partitions as shown and are fastened in place with screws from the inside.

The top back board has a tenon on each end that fits into the mortises in the back posts and is rounded at the top, as shown. The shelf is also rounded at the ends and is fastened to the back with screws.

A glass mirror should be provided for the back. This is fitted to the back board, as shown; then the brackets are put up at the ends of the mirror frame.

The main parts are now ready to be assembled and glued together. Before applying any glue, make sure that all joints fit together perfectly. The end rails and the panels are glued together first and allowed to dry. Make sure the parts clamped together are perfectly square and straight. When these ends are dry, slip them on the tenons on the front and back rails, which are already fastened to the top and bottom boards. The back board and the partitions must be in place when this is done.

The doors are now made by mortising the top and bottom pieces to take the ⅜-inch panel, which is glued in place. The drawers are made as shown in the measured drawing.

The front board should be of oak, but the remainder can be made of soft wood. The joints are nailed and glued. Suitable trimmings or hinges and handles should be found in a specialty hardware store.

The back, made of soft wood, is put on. Scrape all surplus glue from around the joints, and finish with fine sandpaper. Apply stain, if desired.

PIANO BENCH

Materials:

1 top, $1'' \times 16'' \times 36\frac{1}{2}''$
2 end posts, $1'' \times 14'' \times 18''$
1 stretcher, $1'' \times 4'' \times 31\frac{1}{2}''$
2 side rails, $\frac{7}{8}'' \times 4'' \times 29\frac{1}{2}''$
2 keys, $1'' \times 1'' \times 3\frac{1}{2}''$
6 cleats, $1'' \times 1'' \times 4''$

Note: *The dimensions given, with the exception of the keys and cleats, are ½-inch longer than necessary, for squaring up the ends.*

Instructions:

The two rails are cut slanting from a point 1½ inches from each end to the center, making them only 3 inches wide in the middle. The rails are "let into" the edges of the ends so the outside of the rails and the end boards will be flush. The joints are put together with glue and screws. The cleats are fastened with screws to the inside of the rails and to the top. The stretcher has a tenon cut on each of its ends, which fit into a mortise cut in each end post. The tenons will have sufficient length for the small mortise and key.

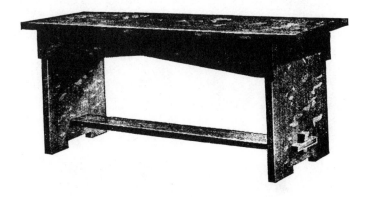

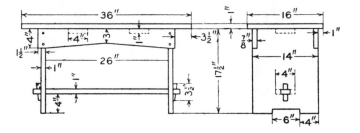

CHINA CLOSET

Materials:

4 posts, 2″ × 2″ × 54″
2 top and bottom boards, ¾″ × 15¾″ × 39½″
2 shelves, ¾″ × 15½″ × 38″
2 lower end braces, ¾″ × 5″ × 15″
2 upper end braces, ¾″ × 4¼″ × 15″
1 lower front board, ¾″ × 3″ × 40″
1 upper front board, ¾″ × 2¼″ × 40″
4 door frames, ¾″ × 1¾″ × 43½″
4 door frames, ¾″ × 2″ × 19″
4 upright end pieces, ¾″ × 1½″ × 39½″
5 back pieces, ½″ × 8″ × 46½″
2 cleats, 1″ × 1″ × 37¾″
4 cleats, 1″ × 1″ × 12¾″
4 blocks, ½″ × 1″ × 1½″

Instructions:

First, be sure the posts are perfectly square and of equal length. Either bevel or round the upper ends as desired. The mortises can be laid out and cut, or they can be left until the tenons are all made, and then marked and cut directly from each tenon.

The top and bottom boards should have the corners cut to clear the posts, as shown in the measured drawing. The top board should be finished on both sides and the bottom one on the upper side only.

Cut the tenons on the front boards back ¼ inch from the face, as shown in the end view. The boards should be finished on the outside sides and edges. The end pieces are fitted and finished in a similar manner, except that the inside edge is rabbeted for the glass, as shown. The side pieces are also rabbeted for the glass, and

the posts have grooves ½-inch deep cut in them to hold these side pieces. They are glued in place after the frame is put together.

The two shelves are finished on both sides and the front edges. The doors are fitted by a tenon and mortise joint at the ends. They are rabbeted on the inside for the glass and are finished on all sides.

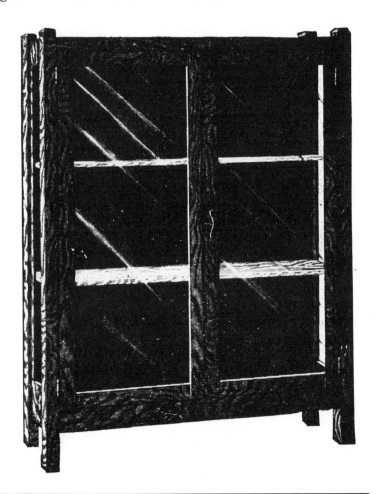

Before gluing any of the parts together, make sure that they all fit and go together perfectly square. The posts, side, and front pieces should be glued and assembled; then the top and bottom boards put in place to hold the frame square when the clamps are put on. Let dry and then scrape any surplus glue from around the joints. Fasten the top and bottom boards to the frame by means of screws through cleats as shown in the measured drawing. The backing is put on and finished on the front side. A mirror can be put in the back without much trouble, if desired.

The shelves should be put in place and held at the back by screws through the backing and at the front by two small blocks on the posts as shown.

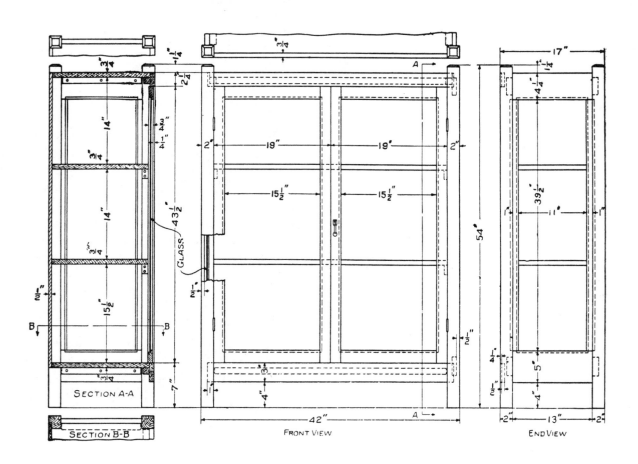

SECTION A-A

SECTION B-B

FRONT VIEW

END VIEW

ANOTHER CHINA CLOSET

Materials:

1 top, 1″ × 19″ × 38″
4 posts, ¾″ × 3″ × 59″
4 side rails, ¾″ × 3″ × 31″
4 end uprights, 1″ × 2″ × 48½″
4 end rails, 1″ × 3″ × 16″
2 lattice rails, 1″ × 2″ × 13″
1 top board, ¾″ × 3″ × 36″
4 side door rails, ¾″ × 2″ × 47″
6 cross rails, ¾″ × 2″ × 12″
4 slats, ½″ × ¾″ × 16½″
4 slats, ½″ × ¾″ × 13½″
8 slats, ½″ × ¾″ × 12½″
4 shelves, ⅝″ × 16″ × 32″
4 cleats, 1″ square × 55″
4 cleats, 1″ square × 28″
4 cleats, 1″ square × 14″

Instructions:

Start with the four posts. Clamp them together, making sure they are of the right length with the ends square. Trim the bottom, as shown in the measured drawing, and then lay out the mortises for the front and back rails. Lay out these rails, and cut the tenons to fit the mortises in the posts. The back rails should, in addition, be rabbeted for the back board, as shown. The side rails are fastened to the posts by means of screws through 1-inch-square cleats, fastened on the inside of the posts. In all cases, the screws should be run through the cleats into the framing so the heads will not show. The end rails should be rabbeted on the inside for the latticework and the glass.

The back board should have the corners rounded and be fastened to the top board with screws. The top board is then fastened to the top rail cleats in the same manner.

The doors are put together by means of tenons and mortises. The frames should be rabbeted on the inside for the latticework and the glass. Leaded glass can be used in place of this latticework, if desired.

The shelves rest on small blocks, which are fastened to the posts. (If desired, small holes can be drilled and pins used instead.)

The back is put on in the usual manner. A mirror can be put in without much difficulty, if desired.

When putting the frame together, glue should be used on the joints because it will make them stiffer. Be careful to get the frame together perfectly square, or it will be hard to fit the doors and the glass. When it is complete, go over the whole carefully with fine sandpaper and remove all rough spots. Scrape all the surplus glue from the joints area.

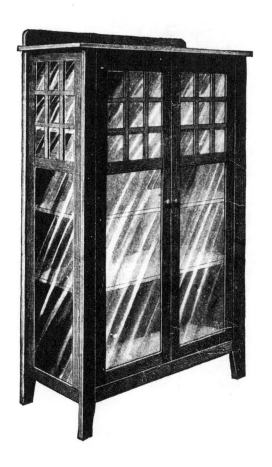

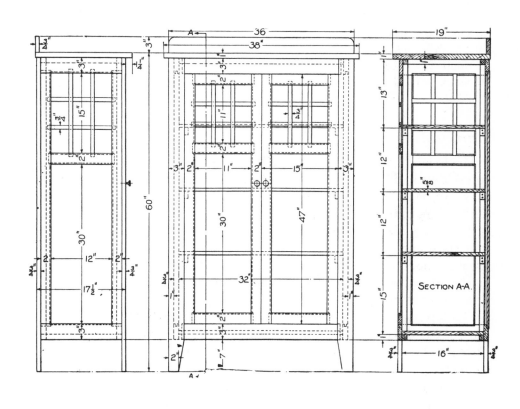

SECTION A-A.

FERN STAND

Materials:

 4 posts, 1½″ × 1½″ × 30″
 8 side rails, ¾″ × 1½″ × 13½″
 2 shelf supports, ¾″ × 1″ × 13½″
 1 top, ¾″ × 16″ × 16″
 1 shelf, ¾″ × 15″ × 15″
 16 slats, ⅜″ × 3″ × 5″

Instructions:

The legs are made first. Be sure they are square and of equal length. The mortises can be laid out and cut, or they can be left until the tenons on the side rails are made, then marked and cut from each tenon. The top rails and the slats are exactly alike for the four sides (the table is square). In addition to the tenons on the rails, grooves should be cut in each rail for the ends of the slats, as shown in the cross-section of the measured drawing. The slats are notched to create a diamond pattern.

The top board should have the corners cut out to fit around the posts. It is held in place by means of screws through cleats, which are fastened to the inner sides of the top rails.

The bottom shelf rests on two shelf supports that are mortised into the posts. The top and shelf boards should be of one piece, if possible.

Before gluing the joints, make sure that all the pieces fit together tightly. The posts, rails and slats should be glued and assembled along with the shelf supports; then the top and shelf boards can be put in place to hold the frame square when the clamps are put on.

After the clamps have been removed, fasten the top and bottom boards in place and then go over the stand with fine sandpaper to remove all surplus glue and any rough spots.

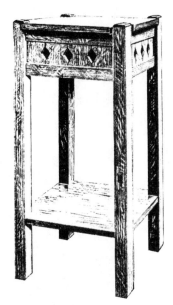

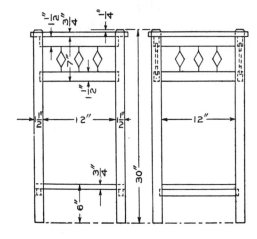

BOOK TROUGH

Materials:

2 ends, 7/8″ × 10″ × 31″
1 shelf, 7/8″ × 10″ × 35″
2 trough pieces, 7/8″ × 4″ × 35″
8 keys, 5/8″ × 5/8″ × 3″

Instructions:

The two end pieces should be made first, with the top corners rounded off; the lower end, which is of a simple design, can be cut out with a jig saw and smoothed with a wood rasp. The mortises should then be laid out according to the measured drawing. Cut them by first boring ¾-inch holes; finish with a chisel. Be careful to keep all the edges clean and free from slivers.

The shelf can now be made. Cut a double-key tenon at each end to fit the end pieces. The space between the two tenons at each end can be cut out with a jig saw and finished with a rasp.

The key holes should be mortised. The trough pieces are made in a similar manner. Be careful to have all tenons and mortises perfectly square and well-fitting.

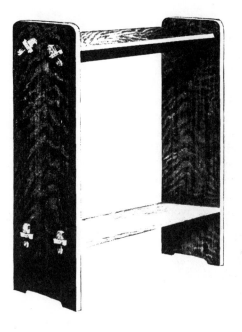

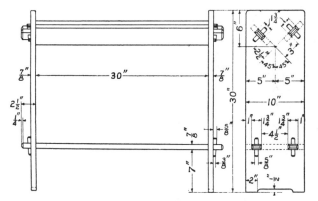

BOOKCASE

Materials:

 1 top (hardwood), ¾″ × 15″ × 31¼″
 1 top back board, (hardwood), ¾″ × 4″ × 30¼″
 2 sides (hardwood), ¾″ × 14″ × 50″
 1 bottom (hardwood), ¾″ × 14″ × 28¾″
 1 bottom rail (hardwood), ¾″ × 4″ × 28¾″
 1 center piece (hardwood), ¾″ × 2″ × 45¾″
 4 door sides (hardwood), ¾″ × 1½″ × 45¼″
 4 door ends (hardwood), ¾″ × 1½″ × 14″
 4 pieces door lattice (hardwood), ½″ × ½″ × 12½″
 4 pieces door lattice (hardwood), ½″ × ½″ × 7″
 2 bottom cleats (softwood), 1¼″ × 1¼″ × 13″
 2 top cleats (softwood), 1″ × 1″ × 12½″
 3 shelves (softwood), ½″ × 12″ × 28½″
12 pieces backing (softwood), ⅜″ × 4″ × 29¾″
 4 hinges
 2 door handles

Instructions:

Begin with the sides, cutting them so they will pair up. The front edges are rounded, and the back edges are rabbeted on the inside as deep as the backing to be used. The bottoms are cut as shown in the measured drawing. Holes about ½ inch deep should be bored on the inside at the proper places for the wooden pegs, which hold up the shelves.

The top and bottom boards should have the front edges rounded and sanded the same as the sides.

The top board is sanded on one side only. Now cut and fit the top back board. This is fastened to the top by means of screws. Screw two cleats to each of the sides as shown, run screws through these into the top and bottom boards, and the frame is completed.

The backing is now put on. Next, put in the center upright piece between the doors, by means of a tenon and mortise at the top and a nail at the bottom. The front edge should be rounded and the edge and sides sanded. Cut and fit the bottom rail as shown. It is fastened to the frame by means of cleats on the back side.

The doors are put together by means of a tenon and mortise. They should be rabbeted for the lattice work and the glass. This lattice work can be omitted and leaded glass put in its place.

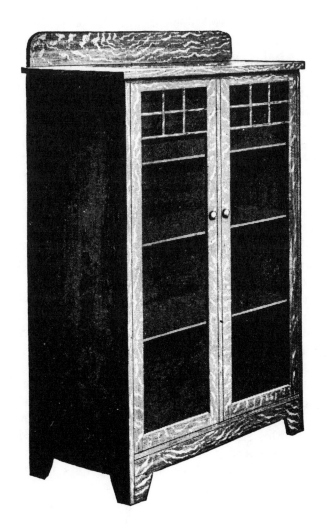

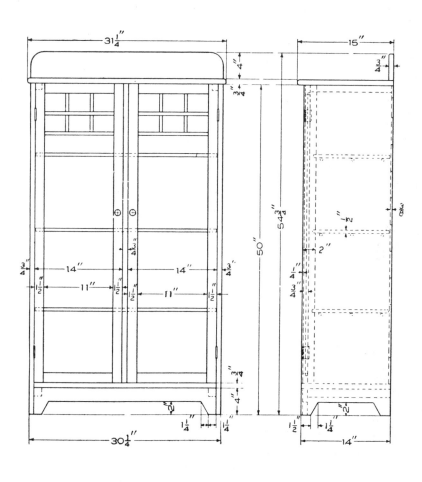

LADY'S WRITING DESK

Materials:

2 front posts, 2″ × 2″ × 30″
2 back posts, 2″ × 2″ × 50″
1 bottom rail, ¾″ × 3″ × 31″
2 end rails, ¾″ × 3″ × 18″
1 stretcher, ¾″ × 8″ × 33½″
2 end slats, ⅜″ × 8″ × 33½″
1 back slat, ⅜″ × 8″ × 15½″
2 back slats, ⅜″ × 3″ × 15½″
1 front drawer rail, ¾″ × 1¼″ × 31¼″
2 side drawer rails, ¾″ × 3″ × 18¼″
1 drawer front, ¾″ × 6″ × 30″
1 desk lid, ¾″ × 18″ × 31¼″
1 desk board, ¾″ × 19¼″ × 31¼″
2 end boards, ¾″ × 19″ × 21¼″
1 top board, ¾″ × 10″ × 34″
1 top back board, ¾″ × 5″ × 31¼″
1 back board, ¾″ × 30″ × 22″
2 drawer sides, ½″ × 6″ × 29″
1 drawer bottom, ½″ × 18″ × 29″
2 pieces for pigeon holes, ⅜″ × 7″ × 23″
8 pieces for pigeon holes, ⅜″ × 4″ × 6¾″

Instructions:

Start with the back posts; be sure they are square and of the right length. Place them side by side, and lay out the mortises for the lower rails, the desk rails and the top back boards, as shown in the measured drawing. Lay out the front posts in the same manner. Cut the tenons on the ends of the rails to fit the mortises in the posts. Also, cut mortises in the rails for the back and end slats. The end rails have a mortise in them for the tenons on the ends of the foot boards. Clamp the ends of the desk together with the end rails in place; then fit the side boards. Bore holes through the posts into the side boards for dowels, as shown. After the dowels are in place, the holes can be plugged.

Cut and fit the top back board, the bottom rail, the back board and the stretcher (the mid-piece in the back, stretching the posts apart). Cut the top and desk boards at the back corners to clear the posts. The top board is to be fastened to the side boards with blind screws (screws which have been counter-sunk and plugged, and can't be seen). The back board is fastened to the posts with dowels, as shown.

When all the parts fit tightly, they can be glued together. The ends of the desk should be glued up first and left to dry, then the other parts put in place and glued. When clamping the parts together, make sure that they fit very tightly.

While the glue is drying, the drawer can be made. The front board is made of oak, but the other parts may be made of pine. The side pieces are mortised and glued to the front board. The end and bottom boards can be nailed together.

The drop lid of the desk is made, as shown. Two or more boards may have to be glued together for the lid, the desk bottom and the back board, if large lumber is not available. The lid is fastened to the desk board with two hinges, and it should be arranged so that when closed, it will be even with the sides. Brackets or chains are fastened to the inside to hold it in the proper position when it is open. Small blocks of wood fastened to the inner edge of the side boards will prevent it from closing too far. A lock, if desired, can be fitted in place. Drawer handles should also be fitted in place.

The pigeonholes are made from the ⅜-inch stock. They may be tacked in place after the desk is finished.

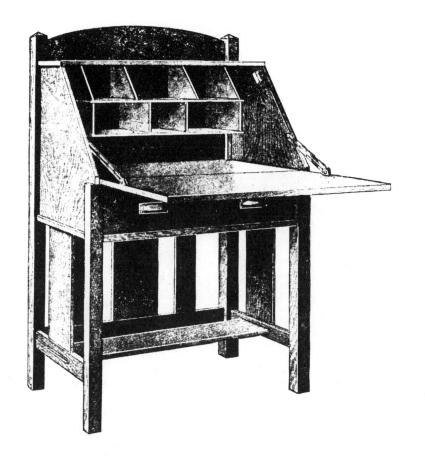

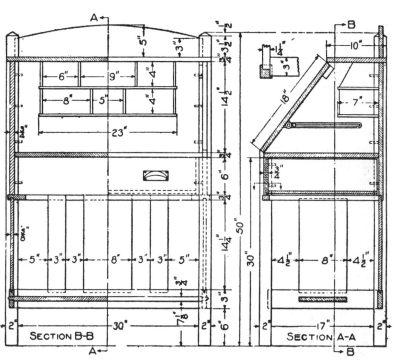

WRITING DESK

Materials:

For an authentic representation of this Writing Desk, well-seasoned quarter-sawn white oak and poplar are the best woods to use. The thicknesses of all the pieces are specified. On the legs the widths too are specified.

Oak:

2 front posts, 1⅝″ × 1⅝″ × 34″
2 back posts (oak), 1⅝″ × 1⅝″ × 42″
2 lower side rails (oak), ¾″ × 3¼″ × 15″
1 lower back rail (oak), ¾″ × 3¼″ × 27″
2 sides (oak), ¾″ × 9″ × 14″
2 sides (oak), ¾″ × 10½″ × 14″
1 back (oak), ¾″ × 9″ × 26″
1 back (oak), ¾″ × 10½″ × 26″
1 top (oak), ¾″ × 6″ × 30″
1 lid (oak), ¾″ × 15″ × 28″
2 side shelves (oak), ¾″ × 5″ × 16″
4 braces (oak), ¾″ × 1¼″ × 9″
1 bottom of case (oak), ¾″ × 16″ × 28″

Interior:

1 piece (oak), ¾″ × 16″ × 27″
4 drawer and case bottom supports (oak), ¾″ × 2½″ × 28″
6 drawer and case bottom supports (oak), ¾″ × 2½″ × 16″
4 drawer guides (oak), ¾″ × ¾″ × 16″

Drawers:

2 front pieces (oak), ¾″ × 7½″ × 13″
4 side pieces (poplar), ⅜″ × 7½″ × 16″
2 back pieces (poplar), ⅜″ × 7″ × 12″
2 bottom pieces (poplar), ⅜″ × 16″ × 12″

Pigeonholes:

1 bottom (poplar), 3/16″ × 7¼″ × 27″
1 top (poplar), 3/16″ × 4½″ × 27″
4 verticals (poplar), 3/16″ × 7¼″ × 10″
1 vertical (poplar), 3/16″ × 4½″ × 4″
5 horizontals (poplar), 3/16″ × 7½″ × 9″
2 horizontals (poplar), 3/16″ × 4½″ × 9″

(continued on page 90)

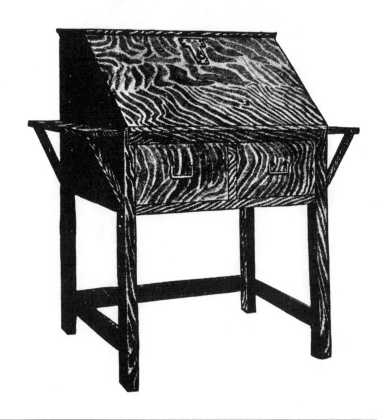

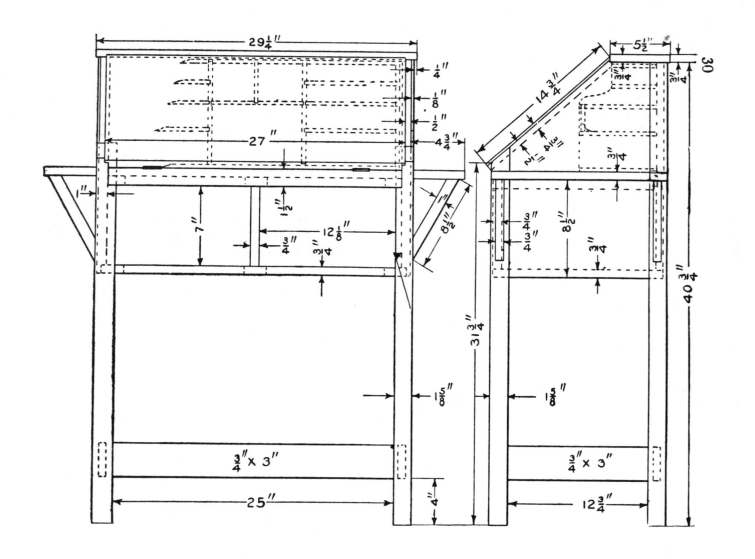

Instructions:

Begin work by cutting the posts to length and shape. Next, lay out the tenons on the lower rails so you have the required distances between the shoulders; then cut them. Now cut the parts to be worked into the frames that support the drawer and bottom of the case, and glue them properly. While this is drying, the other parts of the case may be laid out and shaped. The sides of the case should splice on the edge of the bottom of the pigeonhole case. The side shelves will then cover the joint on either end. The back may be made of one solid piece. Make the side pieces of the case long enough to be housed in the posts about ⅜-inch at each end.

The shelves at the ends of the desk should be fastened after the frame is put together and before the bottom of the case for the pigeonholes is fitted and fastened. When doing this, the shelves may be fastened from the inside

of the case. The angles of the braces are 30-60 degrees. Note that the edges of the lid are rabbeted. You could also have the lid large enough to fit entirely over the sides of the case and then change the slope to correspond.

The drawers are next. The fronts should be of oak, but the other parts should be constructed of poplar as noted in the Materials listing. Their construction is that of an ordinary drawer.

Make the frame of the pigeonholes of 3/16-inch poplar. The measured drawing shows an arrangement entirely independent of the sides of the desk so that the frame can be made and slipped into place after the finish has been put on. Two drawers are shown. These are faced front and back alike so as to secure as much room in the drawer as possible.

MANTEL CLOCK

Materials:

1 front, ⅜″ × 6½″ × 8½″
1 back, ⅜″ × 6½″ × 8½″
1 piece, 5″ wide, 6″ long with a thickness sufficient
 for the clock movement

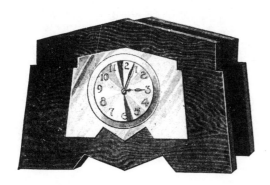

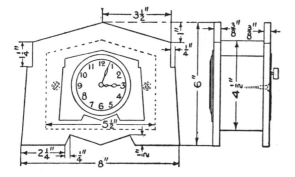

After the front and back pieces are finished, and a piece of hammered copper screwed on the front as shown in the measured drawing, the middle piece must be made just thick enough to make the whole distance from the front of the copper to the back of the clock equal to the depth of the movement. Plane one edge on both front and back pieces. Lay out the design and the centers for the circular holes from this planed edge. Use a plane and chisel to cut the outside design. The hole can be bored out with an expansive bit, or sawed out with a scroll saw, and filed perfectly round. The bit will give the best results. If it is used, bore holes in a piece of scrap wood until the exact size is found.

The outside design of the piece of copper is made to correspond to the design of the clock. The circular hole in the copper can be cut with the expansive bit by first punching a hole in the center to receive the spur of the bit, placing on a block of wood and boring through a little way. The spur on the cutter will cut out the copper. Fasten the copper to the front with copper nails or round screws.

The three pieces of wood can then be glued together. The important thing to remember is that the movement selected must be wide enough from the front to the back to allow the clock case to be made deep enough for standing without being easily upset.

ROLL-TOP DESK

Materials:

- 68 lineal feet of 1″ × 3″ (hardwood)
- 65 lineal feet of 1″ × 2″ (hardwood)
- 3 lineal feet of ¼″ × 24″ (hardwood)
- 45 lineal feet of ¼″ × 10½″ (hardwood)
- 36 lineal feet of 1″ × 12″ (hardwood)
- 35 lineal feet of ⅜″ × 9″ (softwood)
- 100 square feet of ½″ × 12″ (softwood)
- 1 piece, 34″ wide and 54″ long (hardwood)
- 30 pieces, 1″ × 1″ × 48″ long

Instructions:

The upper and lower back panels are very similar, the only difference being in the height. The inside edge of the 3-inch pieces, and both edges of each 2-inch piece, are edged or grooved with a router's ¼-inch bit, ⅜ inch deep exactly in the center. The 16-inch pieces in the upper back panel and the 24-inch pieces in the lower back panel must be cut ½-inch longer and a ¼-inch tongue made on each end to fit into the plowed groove to form a mortise joint.

The upper back panel is filled in with four boards 9½-inches wide and 16½-inches long, while the four boards in the lower back panel are 9½-inches wide and 24½-inches long—all cut from the ¼-inch hardwood. When the grooves are cut properly, the joints made perfect and the boards fitted to the right size, these two panels can be assembled and pressed together with cabinet clamps. This will make the outside dimensions as given in the measured drawing.

The end panels are made in a similar manner to the lower back panel, the only difference being in the width of the filling boards, which are 10½-inches for the outside end panels and 10 inches for the inside panels. One end panel and one inside panel make the sides of one pedestal. As the end panels are 1 inch wider than the inside panels, they overlap the back panel and cover up the rough ends of the boards.

A 1-inch piece 2 inches wide is fastened at the top and bottom of each of the end and inside panels, as shown by the dotted lines on the measured drawing. The lower back panel is fastened on by screws through the back and into the ends of these pieces. The bottom pieces have 2-inch notches cut out, as shown, into which to fit two cross-pieces across the bottom of the pedestal for holding the casters.

The top end panels are made as shown in the measured drawing, the inside edge of the pieces being grooved out, making a groove the same size as in the other pieces of the panels. The panel board is cut to the proper shape from the ¼-inch-by-24-inch material. The length given in the materials list will be sufficient if the pointed ends are allowed to pass each other when the design is laid out.

Instead of cutting a groove for the roll-top curtain, make one by fastening a ½-inch-by-¾-inch strip ⅞-inch down from the edge and on the inside of the panel. A thin ¼ × 1¾-inch strip is bent to form the shape of the edge and fastened with round-headed brass screws. A 1-inch piece is fastened at the back and a groove cut into it (as shown by the dotted line), into which to slide

a ¼-inch back board. The top is a 12-inch board 54 inches long.

As both pedestals are made alike, the detail of only one is shown. The drawer slides are made up from 1-inch-square material, with a 2-inch end piece fitted at the back. Dimensions are given for the divisions of each drawer, but these can be changed to suit the craftsman. The detail of the top drawer is shown.

The roll-top curtain is made up from 1-inch pieces ¾-inch thick and 48 inches long, cut in an oval shape on the outside, tacked and glued to a piece of strong canvas

(continued on page 94)

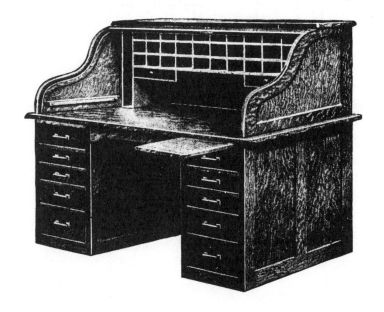

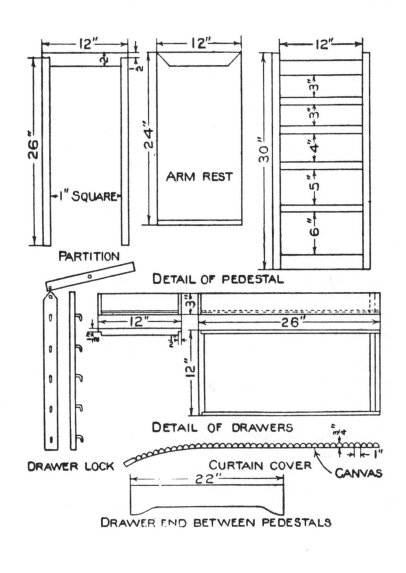

PARTITION

ARM REST

DETAIL OF PEDESTAL

DRAWER LOCK

DETAIL OF DRAWERS

CURTAIN COVER

CANVAS

DRAWER END BETWEEN PEDESTALS

on the inside. The end piece of the curtain is 2 inches wide, into which two grooves are cut and a lock attached in the middle of the edge. A drawer lock can be made as shown, attached to the back panel, and operated by the back end of the roll top curtain when it is opened and closed.

The desk top board, which is 34 × 54 inches, can be fitted with end pieces as shown or left in one piece with the edges made round.

At this point in the construction, the parts can be put together. The sides of each pedestal are fastened together by screws passed through the 1-inch square pieces forming the drawer partitions and into the sides of the panels. After the pedestals are put together, the lower back panel is fastened to them with screws into the pieces provided, as stated in the instructions for making the end panels. The top board is now adjusted, with equal edges projecting, and fastened in position with finishing nails. As the top panels cover directly over the spot where the nails are driven, the heads will not show. The upper back panel is fastened to the curved ends and the whole top held to the top board with corner brackets. The top should not be drawn together too closely before the ¼-inch back board is put in the grooves and the roll top curtain placed in position.

The detail showing the pigeonholes gives sizes for 30 openings, 3 × 4 inches, two book stalls at the ends, 3 inches wide, and two small drawers. This frame is built up as shown from the ⅜-inch softwood, and fastened in the back part of the top with small brads.

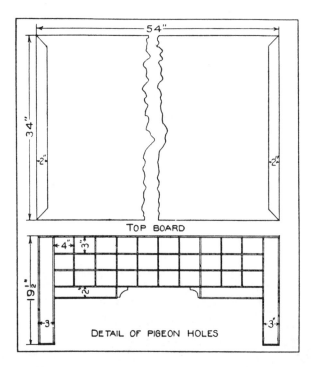

TOP BOARD

DETAIL OF PIGEON HOLES

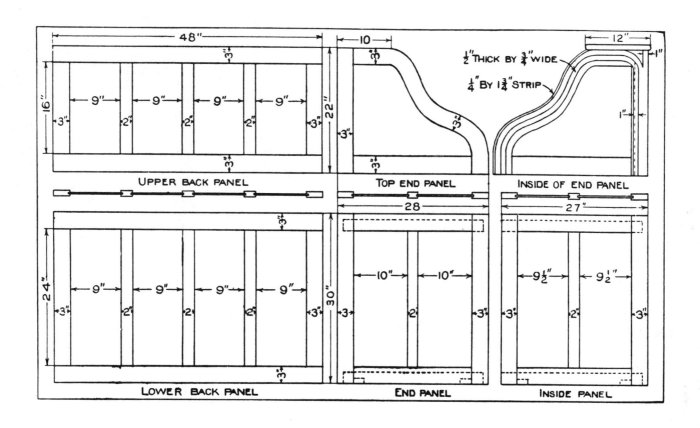

UPPER BACK PANEL

TOP END PANEL

INSIDE OF END PANEL

½" THICK BY ¾" WIDE

¼" BY 1¾" STRIP

LOWER BACK PANEL

END PANEL

INSIDE PANEL

LEATHER-COVERED FOOTSTOOL

Materials:

4 oak posts, 1½″ × 1½″ × 12″
2 sides (softwood), ¾″ × 3″ × 12″
2 ends (softwood), ¾″ × 3″ × 8″
1 bottom (softwood), ¾″ × 8″ × 12″
1 small box of 8 oz. tacks
2½ dozen ornamental head nails
1 piece of warm brown leather, in flat finish, 16″ × 20″
foam for stuffing

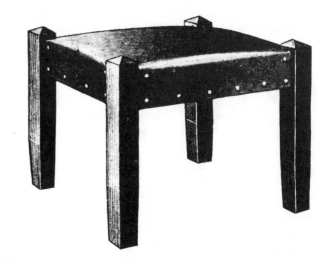

Instructions:

Bevel the top end of each post, and taper the lower ends as shown in the measured drawing. When this is done, the mortises can be cut for the sides as shown in the post detail. When cutting the mortises and tenons, make sure they fit perfectly since there is nothing to brace the legs at the bottom. The strength of the stool depends on the joints.

The parts are now assembled. First, clamp the ends together, using plenty of glue on the joints, and drive some small nails on the inside of the post through the tenon ends. When the glue has set, the remaining sides can be put together the same way as the ends. Fit the bottom on the inside about 1 inch from the top. Drive nails through the sides and ends of the board.

Next, put on the leather seat. Notch out the corners to fit around the posts, but do not cut the ends off. Tuck them under the cover. Before nailing on the cover, fix the foam evenly over the top, about 6-inches deep. Draw the leather over the foam and fasten the edges with the 8-oz. tacks. The ornamental nails are driven in last.

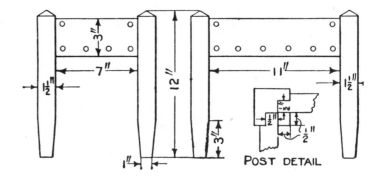

POST DETAIL

FOOTSTOOL

Materials:

1 top, 1″ × 9½″ × 12″
2 legs, ¾″ × 8″ × 12″
1 brace, ¾″ × 7″ × 9″

Instructions:

A full-sized layout of the front view should be made to get the correct bevels for the legs and brace. The design of the legs can vary according to your taste and creativity. For the design shown, draw half of it on paper; fold on the center line and with scissors cut both sides of the outline. Trace around this pattern on the wood, and saw out with a jig saw. The sawed edges should be smoothed and sandpapered.

The hand hole in the top board is made by first boring holes, then trimming out the edges with a sharp chisel. Be sure to get the best side of the board up.

The legs are fastened to the top and to the braces with wood screws as shown in the measured drawing.

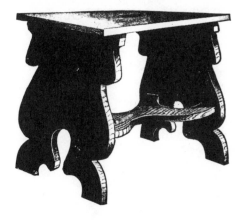

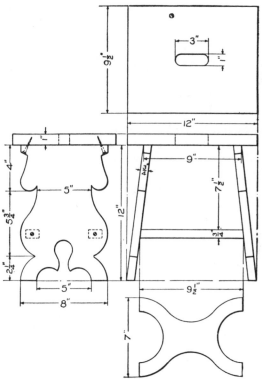

TELEPHONE STAND AND STOOL

Materials:

Stand:

```
 4 posts, 1½" square × 29"
*2 rails, ⅞" × 5" × 11"
*1 rail, ⅞" × 1½" × 13"
*1 rail, ⅞" × 5" × 13"
 2 runners, ⅞" × 1½" × 14"
 1 top, ⅞" × 18" × 20"
 1 shelf, ⅞" × 12⅞" × 13¾"
```

Stool:

```
 4 posts, 1½" square × 17"
*4 rails, ⅞" × 4" × 6½"
*2 rails, ⅞" × 2" × 6½"
 1 stretcher, ⅞" × 4" × 7¼"
 1 top, ⅞" × 12½" square
```

**The joints may be made with dowels, or the mortise and tenon may be used, as desired. If the latter is used, allowance must be made on the length of the rails for the tenons. The list given is for the dowel-made joints. The exact lengths for the posts are given. Should the craftsman desire to square them up, allowance must be made for this when ordering the stock.*

Instructions:

The telephone stand shown in the accompanying illustration is for use with a desk telephone. The stool, when not in use, slides on two runners under the stand. A shelf is provided for the telephone directory, paper, pencil, etc.

Arrange all the pieces in the position they are to occupy in the finished stand and stool, and number all the joints. Locate the centers and bore holes for all the dowels. Assemble the two sides of the table first. Notch the runners and fasten them to the posts with flat screws. Use glue on the dowel joints, if possible.

Cut the corners out of the shelf to fit around the legs, and assemble the frame of the table. Use screws through the rails to hold the shelf. The top may be fastened in two ways, with screws through cleats on the inside of the rails and under the top, or with screws slanting through the upper part of the rails and into the top as shown. The stool is assembled in the same manner as the stand.

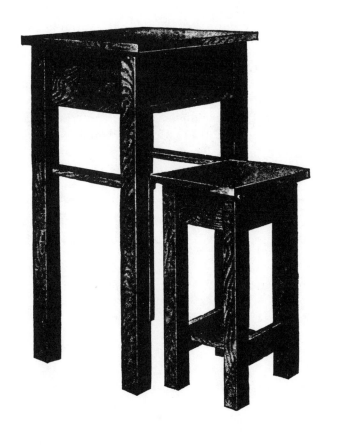

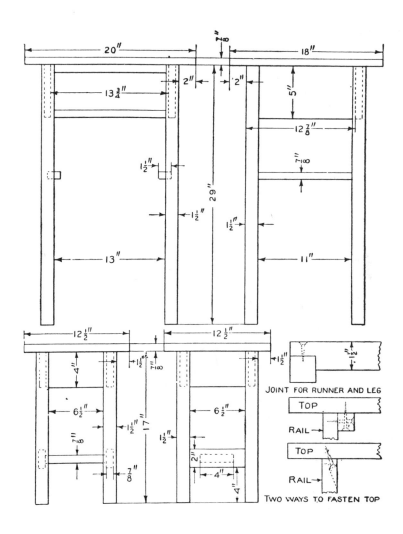

JOINT FOR RUNNER AND LEG

TWO WAYS TO FASTEN TOP

MUSIC STAND

Materials:

1 top, ¾" × 16" × 20"
1 shelf, ¾" × 11½" × 15"
1 shelf, ¾" × 12" × 15"
1 shelf, ¾" × 14½" × 15"
1 shelf, ¾" × 16" × 15"
4 legs, ¾" × 5" × 41"
2 lower crosspieces, ¾" × 3" × 9"
2 upper crosspieces, ¾" × 2" × 9"
4 end slats, ⅝" × 2" × 34"
20 round screws, 2" long

Instructions:

The four shelves and the top are so wide that it may be necessary to make them from two or more pieces glued together. The top should have a ¼-inch bevel cut around the upper edge as shown in the measured drawing.

The curve of the legs can be cut with a bracket saw, making sure that the edges are square and smooth. The four crosspieces are fastened to the legs by means of tenons and mortises. The end slats are joined to the crosspieces in the same manner. The legs can be assembled in pairs with the slats and crosspieces in place. They can be glued in this position. The shelves can now be put in place. They should be fastened to the legs with round screws. The top is also fastened with screws.

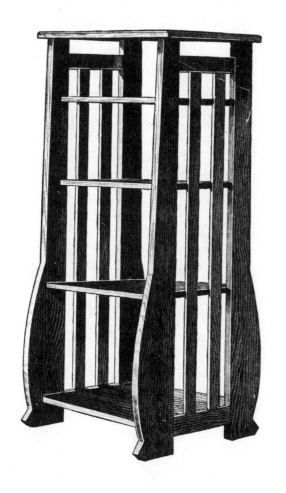

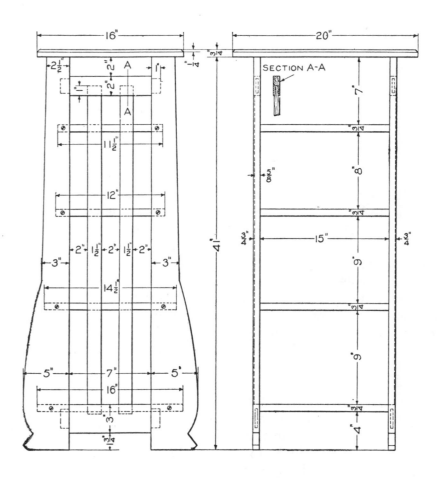

HANGING LIGHT FIXTURE

Materials:

8 pieces, ¾″ × ¾″ × 24″
4 pieces, ¾″ × ¾″ × 4″
4 pieces, ¾″ × ¾″ × 10½″
4 pieces, ⅜″ × ¾″ × 23″
8 pieces, ⅜″ × ¾″ × 10″
8 pieces, ⅜″ × ¾″ × 9″
1 piece, ¾″ × 8″ × 8″
1 piece, ¾″ × 3¼″ × 3¼″

Instructions:

Begin by shaping the ends of the longest pieces as
shown in the measured drawing, at angles of 45 degrees.
Next lay out the cross-lap joints on the corners so that
the two sets of horizontal frames, 23 by 23 inches,
are formed. Shape the ends of the four 4-inch vertical
pieces at angles of 45 degrees. Cut these pieces to a
length of 3 inches. The 3-inch length becomes the vertical
strut between the 23-by-23-inch frames. The shaped end
cut from them becomes their "false" extension, which
is to be fastened below the lower frame at the corners. All
12 of these first pieces should have rabbet joints about
¼ inch in from the edge on the inside of the lamp for
the inset of stained glass. Then assemble this lower frame
with glue and brads. Make the top small horizontal
frame in the same manner as the 23-by-23-inch frames,
but without the rabbet joints. Fit and fasten the top
8-by-8-inch board inside the top frame. This board holds
the light fixture and the hanging chains. The light
fixture selected will require adaptation before the top
frame is assembled to the top board.

Make the 5-piece sloping side as a separate unit, using
the ⅜-inch material. Be sure to make rabbet joints for
stained glass on the inside before assembling. Lap
and glue each of these four 5-piece sloping sides after
making the miter cuts on the sides where they join
together and with the top and bottom frames. Assemble
and glue the sloping sides to the top and bottom frames.
Reinforce the places where they fit together with
copper strips on the inside.

The size and shape of the stained glass should be
determined after the woodwork is completed; a mottled
green color will provide soft light. Insert the light fixture
before fastening chains between the hanging board
and the 3¼-inch square piece.

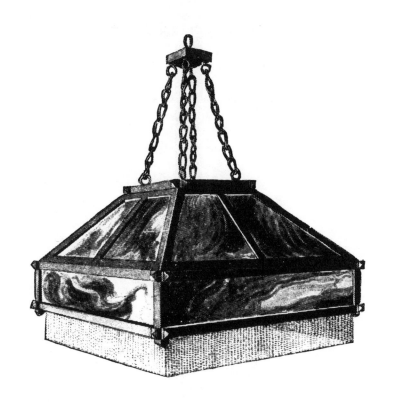

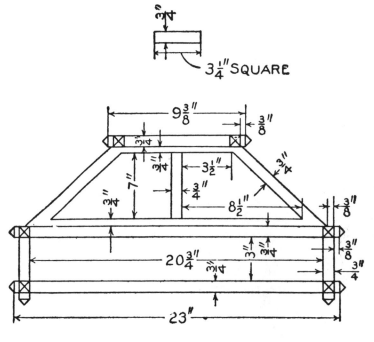

$\frac{3}{4}''$

$3\frac{1}{4}''$ SQUARE

$9\frac{3}{8}''$

$\frac{3}{8}''$

$\frac{3}{4}''$

$\frac{3}{4}''$

$3\frac{1}{2}''$

$\frac{3}{4}''$

$7''$

$\frac{3}{4}''$

$\frac{3}{4}''$

$8\frac{1}{2}''$

$\frac{3}{8}''$

$\frac{3}{8}''$

$\frac{3}{4}''$

$20\frac{3}{4}''$

$\frac{3}{4}''$

$3''$

$\frac{3}{4}''$

$23''$

LAMP STAND

Materials:

1 post, 1½″ square × 23″
1 arm, 1⅛″ × ¾″ × 13½″
1 block, ¾″ thick × 6″ square
1 block, 1″ thick × 9″ square

Instructions:

Square up the base blocks and fasten them together with screws as shown in the measured drawing. A mortise, 1 inch square, is cut in the center of the blocks for the center post. Lead weights, covered with felt, should be attached to the bottom with glue, as shown. The post has a tenon cut on one end to fit the base, and a mortise cut in the other for the arm. Holes are bored in the arm from the ends for the wires. They can be plugged after the wires are in place. A hole is also bored in the top of the center post to connect with the holes in the arm for the lead wire. It is best to glue the joints together, although this is not necessary if the joints are a tight fit.

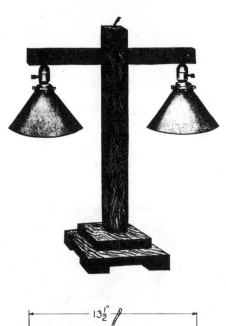

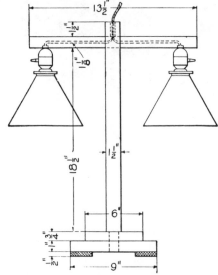

PLATE RACK

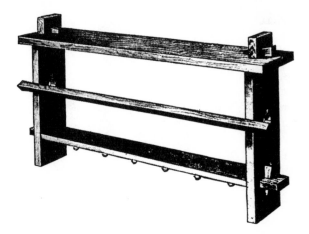

Materials:

2 ends, ⅞″ × 5″ × 20″
1 top, ⅞″ × 6″ × 36″
1 shelf, ⅞″ × 5″ × 36″
4 keys, (scrap pieces will do)

Instructions:

The dimensions of this plate rack may be changed to suit the desired wall space. The parts are held together entirely by keys. The bar across the front is for keeping the plates from falling out, but this may be left out if the plates are allowed to lean against the wall.

Lay out and cut the mortises on the end pieces for the tenons of the shelf as well as the tenons on the top ends and the diamond-shaped openings. In laying these out, work from the back edge of the pieces. Cut the tenons on the ends of the shelf to fit the mortises in the end pieces, numbering each one so the parts can be put together with the tenons in the proper mortises. Mark and cut out the mortises in the top to receive the tenons on the end pieces.

In laying out the mortises for the keys, allow a little extra on the side toward the shoulder so the ends and tops may be drawn up tightly when the keys are driven into the mortises. All the mortises and diamond-shaped openings should be marked and cut with a chisel from both sides of the board.

If the bar is used, it may be attached with a flat side or edge out as illustrated in the measured drawing.

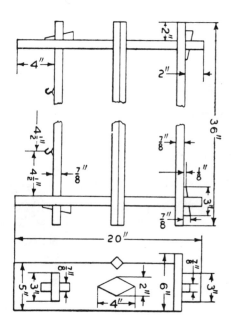

BEDSTEAD

Materials:

- 2 posts, 2½″ × 2½″ × 50″
- 2 posts, 2½″ × 2½″ × 44″
- 2 end rails, 1″ × 6″ × 56″
- 2 side rails, 1″ × 6″ × 78″
- 5 end rails, 1″ × 4″ × 56″
- 3 end rails, 1″ × 2″ × 56″
- 8 vertical slats, ⅜″ × 6″ × 11½″
- 10 vertical slats, ⅜″ × 2″ × 11½″
- 2 cleats, 1″ × 1″ × 78″
- 5 slats, ¾″ × 3″ × 55½″
- 20 blocks, 1″ × 1″ × 3″

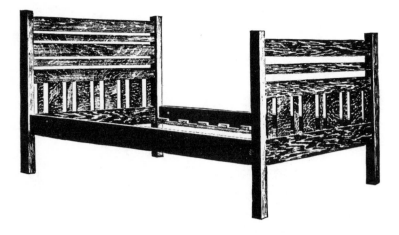

Instructions:

Square up the four posts in pairs and lay out the mortises as seen in the measured drawing. To do this, lay them side by side on a flat surface with the ends square and mark them with a T-square. The tenons on the end rails are laid out in the same manner as the posts. Four of the end rails should be marked and mortises cut for the upright slats, as shown in the measured drawing. The tenons on the end rails are about 1 inch long while those on the slats can be ¾ inch long. Fit all the parts together before gluing to see that they fit square and tightly. After the glue has been applied, clamp them together perfectly square.

While the ends are drying, the side rails can be made. These have a 1-inch-square wooden cleat screwed to the inner side for the slats to rest on. If springs are used, five slats will be sufficient. They can be placed where the springs will rest on them. After the position of the slats has been located, nail small blocks at their sides to hold them in place. For fastening the side rails to the posts, suitable hardware can be purchased from a furniture manufacturer. The posts may have to be mortised to receive this hardware.

When the bed is complete, go over it carefully and scrape all the surplus glue from the joints. Remove all rough spots with fine sandpaper; then apply the stain you desire.

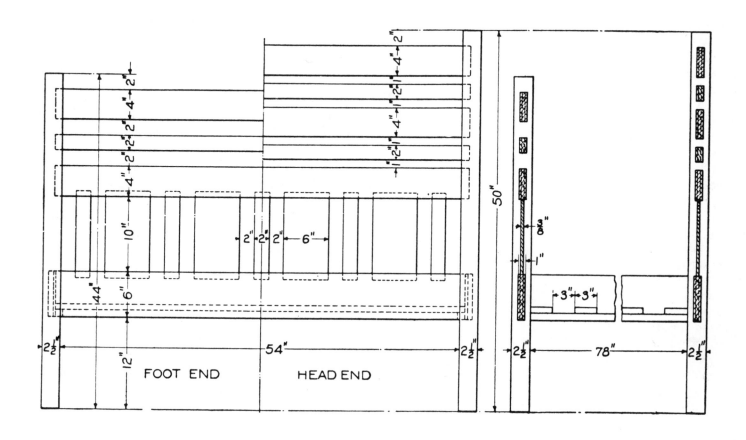

FOOT END　　HEAD END

WARDROBE

Materials:

4 posts, 1¾" × 1¾" × 64½"
2 front rails, ¾" × 1½" × 37½"
1 top and 1 bottom board each, ¾" × 18½" × 37"
1 top back rail, ¾" × 4¼" × 37½"
1 lower back rail, ¾" × 4" × 37½"
6 end rails, ¾" × 6" × 18½"
4 end uprights, ¾" × 4" × 22½"
8 end panels, ⅜" × 7½" × 22½"
5 shelves, ¾" × 17¾" × 19½"
2 drawer fronts, ¾" × 4¾" × 8½"
1 door, ¾" × 7¾" × 10"
1 shelf partition, ¾" × 10" × 19"
2 drawer fronts, ¾" × 7" × 17"
1 drawer front, ¾" × 8" × 17"
1 partition, ¾" × 19½" × 57¾"
4 door uprights, ¾" × 2½" × 57"
2 door top rails, ¾" × 3½" × 14½"
2 door middle rails, ¾" × 6" × 14½"
2 door lower rails, ¾" × 4½" × 14½"
4 door center uprights, ¾" × 2½" × 23"
8 door panels, ⅜" × 6" × 22½"
4 pieces (softwood), ⅜" × 4¾" × 19"
2 pieces (softwood), ⅜" × 8" × 19"
2 pieces (softwood), ⅜" × 4¼" × 8"
4 pieces (softwood), ½" × 7" × 19"
3 pieces (softwood), ½" × 16½" × 19"
2 pieces (softwood), ½" × 6½" × 16½"
2 pieces (softwood), ½" × 8" × 19"
1 piece (softwood), ½" × 7½" × 16½"
1 back, ⅜" × 36" × 58"

Instructions:

First, make sure the posts are perfectly square and of equal length. The upper ends can be beveled or rounded. The mortises should be laid out in each pair of posts, and then cut, or they can be left until the tenons are all made and then marked and cut from each tenon. Grooves should be cut on one side of all the posts, to take the end panels.

The front and lower back rails are plain except for the tenons at each end, but the end rails and the center uprights should have grooves cut for the panels the same as the posts. The top back rail serves as a top back board and should have the corners rounded as shown in the measured drawing.

The frame can now be assembled. Put the panels in the center uprights and then in the rails; then put the rails in the posts. Glue should be used on all joints, as it makes them much stiffer. Be careful to get the frame together perfectly square, or it will be difficult to fit the doors and the shelves.

The top and bottom boards should have the corners cut to clear the posts. These boards are attached to the frame with screws and glue.

The closet is divided into two compartments by a partition. Place the shelves in position as shown. They are held in place by means of cleats and screws. The one shelf has a partition in its center with a door on one side and two small drawers on the other. Drawers should be fitted to three of the other compartments. They are made in the usual manner except that the front boards should be cut out at the top for a handhold.

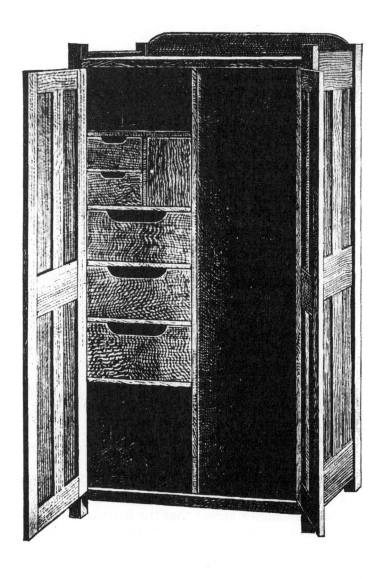

The doors are fitted by a tenon and mortise joint at the ends. They have a centerpiece and panels to match the ends of the closet. Suitable hinges and a catch should be supplied.

When complete, the wardrobe should be carefully gone over with fine sandpaper and all glue and rough spots removed. Apply stain of the desired color.

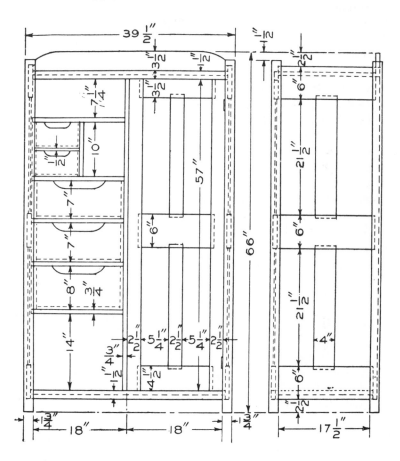

PRINCESS DRESSER

Materials:

4 posts, 1¾″ × 1¾″ × 27″
1 top board, ¾″ × 17″ × 37″
5 side rails, ¾″ × 1½″ × 37½″
4 end rails, ¾″ × 2″ × 17½″
2 end panels, ¼″ × 16¼″ × 16¾″
1 drawer partition, 1″ × 7¾″ × 18½″
1 back board, ¾″ × 4½″ × 36″
2 mirror supports, ⅞″ × 2½″ × 30″
2 side pieces for mirror, ¾″ × 2″ × 42″
2 end pieces for mirror, ¾″ × 2″ × 21½″
2 drawer fronts, ¾″ × 7″ × 17½″
1 drawer front, ¾″ × 7″ × 36″
1 mirror, 20″ × 38″
5 drawer slides (softwood), ¾″ × 2″ × 17″
6 drawer sides (softwood), ½″ × 7″ × 17″
2 drawer bottoms (softwood), ½″ × 17″ × 17″
1 drawer bottom (softwood), ½″ × 17″ × 35½″
1 drawer back (pine), 4½ square feet of ⅜″ wood

Instructions:

First, be sure the posts are perfectly square and of equal length. Either bevel or round the upper ends, as desired. The mortises can now be laid out and cut, or they can be left until the rail tenons are all made and then marked and cut directly from each tenon. The posts and the end rails should have grooves cut in them to make the ¼-inch end panels.

The top board should have the corners cut to fit around the posts. The corners of the back board should be rounded as shown in the measured drawing.

The end sections of the dresser can be glued together first. When these are dry, the side rails and drawer slides can be fitted and glued in place. The top board is held in position by means of screws through cleats, which are fastened to the inner sides of the rails.

The mirror frame is made by mortising the end pieces with the side pieces. It is rabbeted on the back to hold the 20 × 38-inch mirror. After the mirror is securely fastened in the frame, a thin wood covering should be tacked on the back to protect the glass. The frame swings between two upright posts, which are securely fastened to the body of the dresser, as shown.

The drawers are made and fitted. The measured drawing illustrates two drawers in the top compartment, but one exactly like the lower one can be made and used by simply eliminating the 1-inch partition.

The back is made of pine or another softwood and is put on in the usual manner. Care should be taken to remove all surplus glue. Finish smooth with fine sandpaper and apply the stain desired.

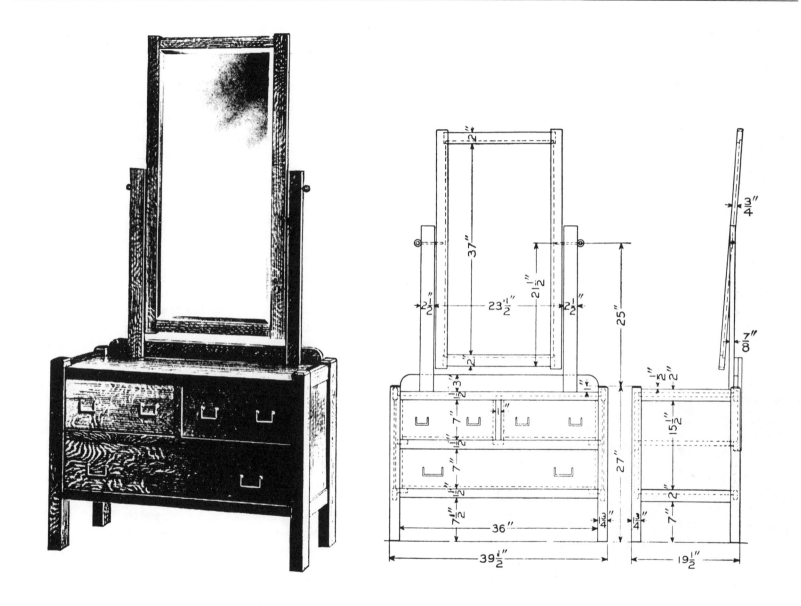

CEDAR CHEST

Materials:

2 top and bottom pieces (cedar), ⅞" × 16½" × 34½"
2 sides (cedar), ⅞" × 18⅞" × 34½"
*2 ends (cedar), ⅞" × 18⅞" × 14¾"
2 overhanging top pieces (oak), 1" × 1" × 36½"
2 overhanging top pieces (oak), 1" × 1" × 18½"
2 lock and hinge rails (oak), 1" × 2½" × 36½"
2 lock and hinge rails (oak), 1" × 2½" × 18½"
2 base pieces (oak), 1" × 3¼" × 36½"
2 base pieces (oak), 1" × 3¼" × 18½"

Note: *The original plans call for thoroughly seasoned Tennessee red cedar and plain-sawed white oak. The Materials listing allows a half-inch extra on the length and the width of each piece for "squaring up" of all pieces except those marked to be surfaced on four sides.*

For the dovetail joint it will be necessary to add 2 inches more to the length of the end pieces, making them 16¾" each in the rough.

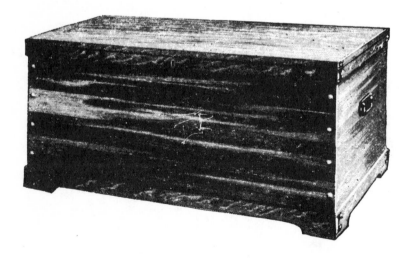

Instructions:

Begin by squaring the sides and ends to size. Probably the best joint for the corners is the dovetail. The measured drawing calls for the simplest form of joint, in which the sides of the chest lap over the end.

With the sides and ends ready, fasten them together. The perspective shows the sides fastened to the ends with ornamental headed nails, which cover the heads of common nails.

Next, square the bottom and nail it to the parts just assembled. Square the top to the same size.

The upper edge of the base is to be beveled or sloped ⅛-inch to facilitate cleaning and for appearance. Fit these base pieces in place, mitering the joints. Before fastening the parts to the chest proper, gauge a line ¾ inch from the lower edge and to a point 4½ inches from each end, cut out to this line and shape the base as shown in the measured drawing. Use finishing nails for fastening the base to the chest. The heads should be "set" so they may be covered later with a putty colored to match the finish.

In a similar manner, cut and fit the lock and hinge rails. These rails should be kept a scant ⅛ inch below the top edges of the chest proper. The overhang of the lid fits down over in such a way as to form a dust-proof joint between lid and chest.

The overhang of the lid, of 1-inch-by-1-inch stock, may next be mitered, fitted and nailed to the lid.

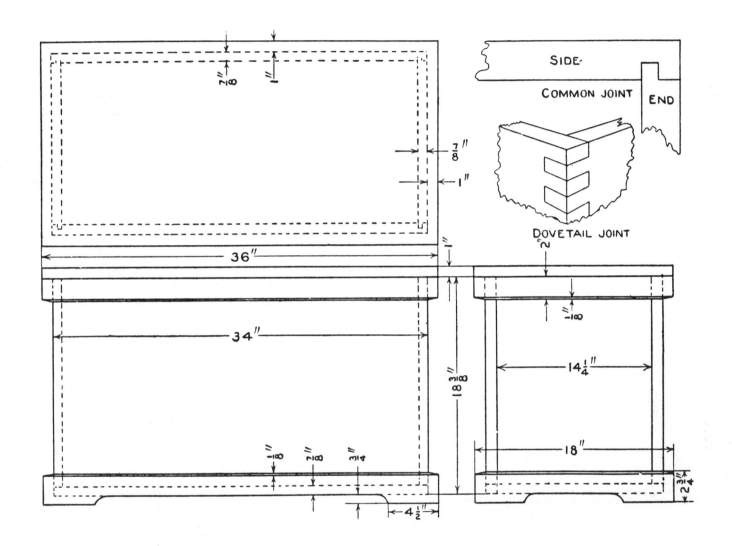

SIDE·

COMMON JOINT END

DOVETAIL JOINT

$\frac{7}{8}''$

$1''$

$\frac{7}{8}''$

$1''$

36"

34"

$\frac{1}{8}''$

$\frac{7}{8}''$

$3\frac{1}{4}''$

$4\frac{1}{2}''$

$1''$

$18\frac{3}{8}''$

$2''$

$\frac{1}{8}''$

$14\frac{1}{4}''$

18"

$2\frac{3}{4}''$

SHAVING STAND

Materials:

4 posts, 1¼" square × 50½"
4 slats, ⅞" × 1" × 32½"
2 cross rails, 1" × 1½" × 15"
2 end rails, 1" × 1½" × 13"
1 top, ⅞" × 16½" × 19½"
1 bottom, ⅞" × 15" × 17"
2 ends, ⅞" × 12½" square
1 back, ⅞" × 12½" × 14½"
1 door, ⅞" × 6½" × 12½"
2 drawer ends, ⅞" × 6" × 7½"
1 partition, ⅞" × 12" × 14"
1 partition, ⅞" × 7" × 14"
7 pieces of softwood, ½" × 7½" × 12"
2 posts, 1" square × 10½"
1 bottom piece, ⅞" × 1½" × 18½"
4 mirror frame pieces, ⅞" × 1½" × 14½"
2 sticks for pines
2 hinges
1 lock
2 drawer pulls
1 beveled glass mirror, 11½" square

Note: The list of materials has dimensions ½-inch larger in some instances for dressing and squaring where necessary.

Instructions:

The tenons and mortises are first cut for the cross-pieces at the bottom of the posts, and, as it is best to use dowels at the top, holes for pins are bored in the bottom piece and in the ends of the slats. The bottom must have a square piece cut out from each corner almost the same size as the posts. The bottom piece is then fastened to the posts with dowels. The end board and posts can be doweled and glued together, and after drying well, the posts can be spread apart far enough to insert the bottom rail and two slats. The rail and slats should be tried before putting on any glue, which may save some difficulty.

After the sides are put together, the back is put in and glued. The top is then put on and fastened with cleats from the inside. The partitions are put in as shown and the door fitted. Two drawers are made from the ends and the softwood material. The drawer ends may be supplied with wood pulls of the same material or matched with metal of the same sort used for the hinges.

The pieces for the mirror frame should be rabbeted ½-inch deep to take the glass, and the ends should be joined together with a miter at each corner. The two short posts are tenoned and mortises are cut in the bottom piece for joints, which are glued. The bottom piece is then fastened to the top board of the stand. This will form the standards in which to swing the mirror and its frame. This is done with two pins inserted into holes bored through the standards and into the mirror frame.

After the parts are all put together, cleaned and sandpapered, the shaving stand is ready for the finish.

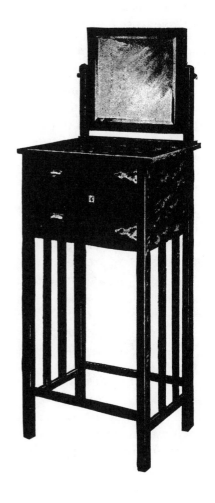

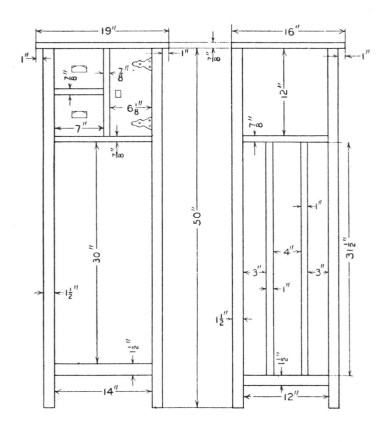

WALL CASE

Materials:

2 sides, ⅝″ × 6″ × 32½″
1 top and 1 bottom, ⅝″ × 6″ × 18″
1 top of back, ½″ × 4″ × 16¼″
1 bottom of back, ½″ × 3″ × 16¼″
1 shelf, ⅝″ × 5″ × 16″
1 back, ¼″ × 16″ × 21″

Door:

2 stiles, ⅝″ × 3″ × 20½″
1 top rail, ⅝″ × 2″ × 11″
1 bottom rail, ⅝″ × 4″ × 11″
1 backing for door, ⅜/16″ × 10″ × 15″

Instructions:

First, shape the ends of the two side pieces as shown in the measured drawing. Next, square the top and bottom pieces of the case to size, and lay out and cut the tenons on the ends. Lay out and cut the mortises in the side pieces as well as the groove for the shelf, after having squared the shelf to size. Cut and shape the top and bottom pieces of the back as shown. Cut rabbet joints in the side pieces for these top and bottom pieces and for the back. Thoroughly scrape and sandpaper these parts and assemble them. Cut and fit the back in place.

Next, make the door. Plan the different parts of the door so that the edges may be planed to fit the opening; that is, make the door a good quarter-inch larger then the opening at the top and bottom. In cutting the rabbet joints, the easiest way is to use a rabbeting plane and cut the full length of the pieces.

The wood should be finished before the glass is set. In setting the glass, place a thin cushion of putty between the joint and the glass and another thin cushion between the glass and the wood backing.

Fit the door, and then put on the hinges and lock. If desired, the tenons may be made keyed as shown in the illustration.

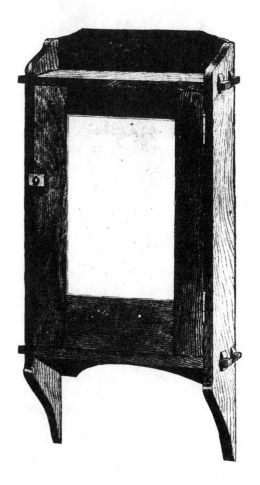

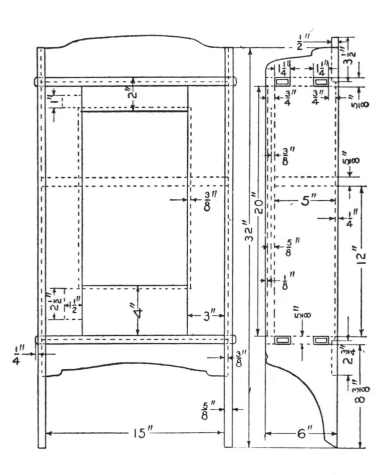

MEDICINE CABINET

Materials:

4 posts, 1½″ × 1½″ × 28″
4 side rails, ¾″ × 2″ × 16″
4 end rails, ¾″ × 2″ × 7″
2 door rails, ¾″ × 2″ × 15″
2 door rails, ¾″ × 2″ × 22¾″
1 door panel, ¼″ × 11½″ × 19¼″
1 back panel, ¼″ × 15½″ × 23¼″
2 end panels, ¼″ × 15½″ × 23¼″
2 pieces for top and bottom, ½″ × 6¾″ × 15¾″
Shelves (softwood), as desired

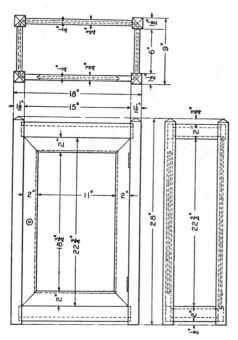

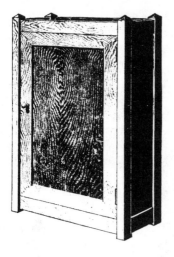

Instructions:

Square the four posts and bevel the tops as shown. Cut grooves in them to receive the ¼-inch panels. The tenons on the rails are cut ¼ inch wide and fit into the grooves in the posts the same as the panels. The front posts do not have grooves on the inside but have two mortises, one at each end, for the top and bottom rails. The back has a panel fitted in the same way as the ends. See that the pieces fit together perfectly square and tightly. Then glue them together.

The top and bottom boards are next put in place. The top is placed in the center of the top rails while the bottom is put even with the lower edge of the bottom rails, as shown in the measured drawing.

The door frame is mitered at the corners and rabbeted on the inner edge to take the panel. A mirror can be used in place of the panel, if desired. Suitable hinges and a catch can be purchased at a hardware store. Shelves can be arranged, as desired.

WASTE PAPER BASKET

Materials:

 1 bottom piece, ¾″ × 9″, square
 4 corner pieces, ¾″ square × 15½″
 4 top rails, ¾″ square × 7½″
12 slats, ¼″ × ¾″ × 16¼″
 4 blocks, 1″ square
 4 flat headed screws, 2½″ long
24 round headed screws, ¾″ long
 4 dowel pins ⅜″ round × ¾″ long

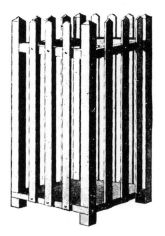

Instructions:

First, bevel the ends of the corner posts and the slats, as shown, and finish them with sandpaper. Bore the holes in the posts and the railing for the dowel pins. These pins should be about ⅜ inch in diameter and ¾ inch long. When this is done these parts can be glued together and laid aside to dry.

The four blocks are for the feet. Bore holes through these blocks and the corners of the bottom board for the large screws. Fasten them together by running the screws through the blocks and the board, and into the ends of the corner posts, as shown in the measured drawing.

The ¼-inch slats can now be fastened on with the small round-headed screws. They should be evenly spaced on the four sides.

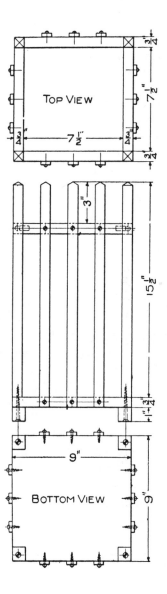

TABOURET

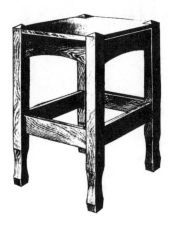

Materials:

4 legs, 1½" × 1½" × 22"
1 top, ¾" thick × 14" square
4 top rails, ¾" × 4" × 12"
4 lower rails, ¾" × 3" × 12"

Instructions:

Square up the four legs. Bevel the tops at an angle of 30 degrees. Bevel and hollow out the lower part of the legs, as shown in the drawing. Clamp them together with the ends square and lay out the mortises all at once. Cut the tenons on the rails to fit these mortises. Lay them out in the same manner as the posts so as to get them all the same. The upper rails should be cut out underneath, in a curved shape.

Glue together the rails and posts. Make sure they are perfectly square. When they are dry, cut and fit the top. This is fastened to the top rails by means of screws from the inside. Remove all surplus glue and go over the whole with fine sandpaper.

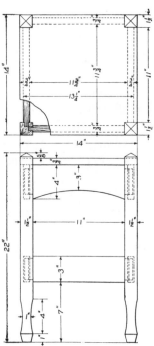

Chronology

The Red House.
(William Morris Gallery.)

William Morris.
(William Morris Gallery.)

1819 Birth of John Ruskin, critic and author, who stressed the necessity of distribution and economic co-operation in his works on the social good.

1834 Birth of William Morris.

1848 Formation of the Pre-Raphaelite Brotherhood, a group that painted *genre* subjects full of moral content. The artists examined the burning questions of the day and gave every pictorial detail a significance.

1859 Morris built a home for his wife and himself, the famous Red House, on the outskirts of London. He designed and executed the decoration and furniture himself.

1861 Morris opened a firm, Morris, Markshall, Faulkner & Co., in order to provide sturdy and simple furniture, which he felt was unobtainable at the time. This firm's products were to usher in a new era in decorative arts.

1868	Charles L. Eastlake wrote *Hints on Household Taste*, urging a restrained decoration and honesty in construction. The book became very popular in England and the United States and helped popularize new design principles.
1876	Centennial Exposition in Philadelphia.
1879	Louis C. Tiffany & Co., Associated Artists founded in New York with the help of Candace Wheeler and the Society of Decorative Arts. During the next years, the firm became one of New York City's most popular decorating concerns.
1880s	The impact of Ruskin's and Morris's teaching crystallized in the guild ideal and the formation of a number of societies to promote this ideal, especially the Art Workers' Guild, in 1885, which organized periodical public exhibitions, and the Guild & School of Handicraft, in 1886, originally a guild of three working craftsmen who taught, and whose pupils later became absorbed into the guild. Later, in 1898, this became The Guild of Handcraft Limited, established in Essex House, Bow. A gallery and salesroom were maintained on Bond Street, London for the permanent exhibition of the Guild's more important work. This was essential because the Guild later moved to Chipping Campden in Gloucestershire.

Elbert Hubbard. (Collections of Greenfield Village and the Henry Ford Museum)

| 1893 | Elbert Hubbard visited Morris's Kelmscott Press, and returned to the United States to found the Roycrofters, named for two seventeenth-century English printers. Morris made an impression on Hubbard that was to influence all of Hubbard's work. |
| | First issue of *The Studio* published in April. It included an interview with C. F. A. Voysey and articles on Morris, Walter Crane, and A. H. Mackmurdo, founder of the Century Guild in 1882, which produced decorative objects in every area of interior design. |

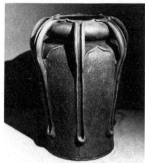

Bulbous-shaped Grueby pottery vase with stylized leaf decoration. (Photograph courtesy Jordan-Volpe Gallery.)

Decorative border by Josef Hoffman for music of Max Bruns' piece, "Small Town Idyll." From Ver Sacrum, *IV, 1901.*

1894	Grueby Faience Company started in Boston. Today it is primarily known for its dark green matte glaze, but it made pieces in a number of varied colors and motifs.
1896	Death of William Morris.
	First issue of *House Beautiful* published in Chicago.
	Tiffany favrile glass was introduced to the New York market for the first time, although it had been produced in the Tiffany Furnaces in Corona, Long Island since 1894.
1897	Major Arts & Crafts exhibition held at Copley Hall, Boston.
	Boston Arts & Crafts Society founded in June.
	Gustave Stickley Company founded in Syracuse (Eastwood), New York. Stickley also visited Europe and met with leading designers, including C. R. Ashbee and C. F. A. Voysey.
	Chicago Arts & Crafts Society formed in October.
1898	The first issue of *Ver Sacrum* (The Sacred Spring) published by the Vienna Secession appeared in January. This was one of the outstanding periodicals of its day, from both literary and artistic viewpoints. Today it is considered a document of the period and an influence on modern Austrian art. Gustav Klimt, founder of the Vienna Secession, was a member of the editorial committee in 1900.
1900	L'Exposition Universelle in Paris.
	John Ruskin died.

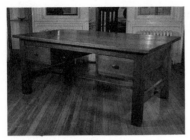

Partner's desk, circa *1905, custom made for use at the L. & J. G. Stickley factory. (Photograph courtesy Robert Edwards Gallery.)*

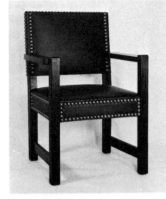

Armchair, Craftsman Workshops, white oak with leather and brass studs. (Photograph courtesy Jordan-Volpe Gallery.)

Providence Art Club, 11 Thomas Street, Providence, Rhode Island. Perhaps the first brick veneer structure in Providence, this three-story dwelling was built by Seril Dodge in 1790; it first was leased to the Art Club in 1886 and then deeded to it in 1906.

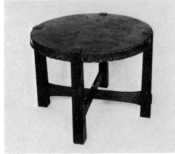

Leather-topped round table, circa *1901, included in the photographs of Stickley's exhibit space at the Pan-American Exposition. (Photograph courtesy Robert Edwards Gallery.)*

L. & J. G. Stickley, brothers of Gustav, formed their own company in Fayetteville, New York.

C. R. Ashbee went on a lecture tour in the United States, where he met Frank Lloyd Wright.

Gustav Stickley showed furniture at the Grand Rapids Exhibition.

Will Bradley, called the American Beardsley, a foremost Art Nouveau draftsman, began the designing of a house for publication in the *Ladies' Home Journal.* Today these designs, which appeared from November 1901 to August 1902, are considered a remarkable combination of the best of the Arts & Crafts interiors with a fluid pattern of Art Nouveau ornament. They served as an example for architects and builders alike in the following decade.

1901 *The Craftsman* magazine published in October.

Furniture shop begun by the Roycrofters.

Arts & Crafts Exhibition at the Providence Art Club, which was described in *House Beautiful* as "having been so successful in realizing the true spirit of the Arts & Crafts revival;" it showed individual objects from craftsmen all over the United States.

Gustav Stickley shared booth space with the Grueby Faience Company of South Boston at the Pan-American Exhibition in Buffalo, New York.

Frank Lloyd Wright delivered his address, "The Arts & Crafts of the Machine," to the Chicago Arts & Crafts Society.

1903 The formal establishment of the *Wiener Werkstätte* (Vienna Workshops), a Viennese craft group along the English guild lines, determined to revive and preserve craftsmanship in the applied arts. Josef Hoffman, architect and former professor at the *Kunstgewerbeschule,* the School of Arts and Crafts associated with the Austrian Museum of Art and Industry, was a

Registered trademark of the Wiener Werkstätte designed by Josef Hoffman and Koloman Moser, 1903.

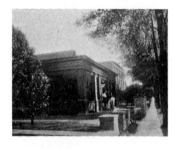

The Roycroft Inn.

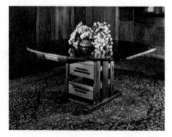

Dining Room table, David B. Gamble House, 1908, architects Greene and Greene. (Marvin Rand photograph, courtesy Greene and Greene Library, The Gamble House.)

prime mover and admirerer of Morris, Ruskin, Ashbee, and Mackintosh of Scotland. With Koloman Moser and wealthy patron Fritz Wändorfer, he established a Viennese equivalent of the English guild, which strove for an "entire art environment." One of their most important projects was the Sanatorium Purkersdorf, 1904-1905; all furnishings, decorations, and appliances were designed by Hoffman and executed by the *Wiener Werkstätte*.

Arts & Crafts Exhibition held at Syracuse, New York in May under the auspices of the United Crafts in the Craftsman's Building, the publishing house of *The Craftsman* magazine. It caused intense interest among those active in the fostering of the decorative and industrial arts.

Roycroft Inn opened in East Aurora, New York.

Craftsman Home-Builder's Club formed, which published monthly suggestions for Craftsman houses and made plans and specifications available upon request.

Candace Wheeler's *Principles of Home Decoration* published in New York.

1905 *The Craftsman* magazine moved to 41 West 34th Street, New York City.

1907 National League of Handicraft Societies founded in Boston in February, organized with thirty-three constituent societies in twenty states from Maine to Oregon.

Greene & Greene, brother architects, began work on the Robert R. Blacker house in Pasadena, California, including design for all furniture and the gardens. This was their first work of great note. In this year, they also started the design of the Gamble House in Pasadena, which they later entirely furnished. Today, the Gamble house is open to the public as a museum on a limited basis, as a permanent monument to their calibre of design and their unique contribution to American architecture.

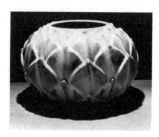

Fulper pottery bowl with stylized plant motif. (Photograph courtesy Jordan-Volpe Gallery.)

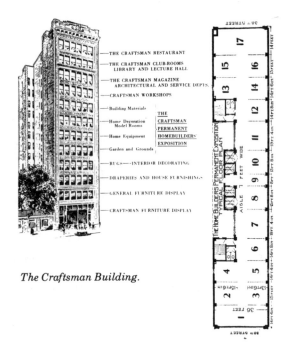

THE CRAFTSMAN RESTAURANT

THE CRAFTSMAN CLUB-ROOMS
LIBRARY AND LECTURE HALL

THE CRAFTSMAN MAGAZINE
ARCHITECTURAL AND SERVICE DEPTS.

CRAFTSMAN WORKSHOPS

Building Materials

Home Decoration
Model Rooms

Home Equipment

Garden and Grounds

RUGS——INTERIOR DECORATING

DRAPERIES AND HOUSE FURNISHINGS

GENERAL FURNITURE DISPLAY

CRAFTSMAN FURNITURE DISPLAY

THE
CRAFTSMAN
PERMANENT
HOMEBUILDERS
EXPOSITION

The Home Builders Permanent Exposition
TYPICAL FLOOR PLAN

The Craftsman Building.

1909	Frank Lloyd Wright designed the dining room for the Robie House in Chicago.

C. R. Ashbee visited California and met the Greenes, whose work, he later wrote, he admired immensely.

Craftsman Homes published by Stickley, to be followed in 1912 by *More Craftsman Homes*.

1910 Fulper Pottery developed an art pottery line, which produced an endless variety of shapes and glazes.

1913 Gustav Stickley moved to 6 East 39th Street, New York City, to a building housing a library, restaurant, gardens, showrooms and lecture hall.

1915 Gustav Stickley enterprises declared bankrupt.

The Hubbards died aboard the *Lusitania* in May.

1916 Last issue of *The Craftsman* magazine in December.

1919 With the publication of the *Program of the Staatliche Bauhaus* in Weimar, a four-page leaflet with a title-page woodcut by Lyonel Feininger and Walter Gropius's Manifesto and Program, a new chapter in decorative arts was inaugurated: the Bauhaus movement.

Selected Bibliography

BOOKS

Adlmann, Jan Ernst. *Vienna Moderne. 1898-1918*. Houston: Sarah Campbell Blaffer Gallery, University of Houston, 1978.

Anscombe, Isabelle and Gere, Charlotte. *Arts & Crafts in Britain and America*. New York: Rizzoli, 1978.

Champney, Freeman. *Art and Glory: The Story of Elbert Hubbard*. New York: Crown Publishers, 1968.

Clark, Robert Judson, editor. *The Arts and Crafts Movement in America 1876-1916*. Princeton: Princeton University Press, 1972.

Craftsman Furniture. Made by Gustav Stickley. Eastwood, New York: The Craftsman Workshops, 1909. Reprint, The American Life Foundation, 1978.

Freeman, John Crosby. *The Forgotten Rebel: Gustav Stickley and His Craftsman Mission Furniture*. Watkins Glen, New York: Century House, 1966.

Hamilton, Charles F. *As Bees in Honey Drown: Elbert Hubbard and the Roycrofters*. New York: A. S. Barnes and Co., 1973.

Hubbard, Elbert. *The Roycroft Shop*. East Aurora, New York: The Roycrofters, 1909.

Hunter, Dard. *My Life with Paper*. New York: Alfred A. Knopf, 1958.

Lynes, Russell. *The Tastemakers*. New York: Harper and Brothers, 1955.

Naylor, Gillian. *The Arts and Crafts Movement*. London: Studio Vista, 1971.

Pevsner, Nikolaus. *Pioneers of Modern Design from William Morris to Walter Gropius*. New York: The Museum of Modern Art, 1949.

Powell, Nicolas. *The Sacred Spring: The Arts in Vienna 1898-1918*. Greenwich: New York Graphic Society, 1974.

Seale, William. *The Tasteful Interlude: American Interiors Through the Camera's Eye, 1860-1917*. New York: Praeger Publishers, 1975.

Shay, Felix. *Elbert Hubbard of East Aurora*. New York: Wise and Co., 1926.

Stickley, Gustav. *Craftsman Homes*. New York: Craftsman Publishing Co., 1909.

————. *More Craftsman Homes*. New York: Craftsman Publishing Co., 1912.

Stickley Craftsman Furniture Catalogs: Unabridged Reprints of Two Mission Furniture Catalogs. New York: Dover Publications, 1979.

Vergo, Peter. *Art in Vienna 1898-1918*. London: Phaidon Press, 1975.

Wheeler, Candace. *Principles of Home Decoration*. New York: Doubleday, 1903.

———. *Yesterdays In a Busy Life*. New York: Harper and Brothers, 1918.

Windsor, H. H. *Mission Furniture: How to Make It. Part I, II, III*. Chicago: Popular Mechanics Company, 1909, 1910, 1912.

PERIODICALS

Beisner, Robert L. "Commune in East Aurora," *American Heritage*, XXII, February 1971, pp. 72-77, 106-109.

Binns, Charles F. "The Arts and Crafts Movement in America: Prize Essay," *Craftsman*, XIV, June 1908, pp. 275-279.

Bohdan, Carol. "Arts and Crafts Copperware," *American Art & Antiques*, March-April 1979, pp. 108-115.

Bohdan, Carol L. and Volpe, Todd M. "Gustav Stickley: The Rebel Craftsman of His Time," *Fine Woodworking*, No. 2, Spring 1976, pp. 44-46.

———. "The Furniture of Gustav Stickley," *Antiques*, May 1977, pp. 984-989.

———. "Collecting Arts & Crafts," *19c Nineteenth Century*, Autumn, 1978, pp. 52-57.

Bragdon, Claude. "Harvey Ellis: A Portrait Sketch," *Architectural Review*, XV, December 1908, pp. 173-183.

Brener, Carol. "Move Over, Deco—Here Comes Mission Furniture," *New York*, January 24, 1977, pp. 49-58.

Macomber, H. Percy. "The Future of the Handicrafts," *American Magazine of Art*, IX, March 1918, pp. 192-195.

Marks, Alan. "Greene and Greene, A Study in Functional Design," *Fine Woodworking*, No. 12, September 1978, pp. 40-45.

Pond, Theodore Handord. "The Arts and Crafts Exhibition at the Providence Art Club," *House Beautiful*, X, June 1901, pp. 98-101.

Priestman, Mabel Tuek (also spelled Tuke). "History of the Arts and Crafts Movement in America," *House Beautiful*, XX, October and November, 1906, pp. 15-16, 14-16.

Sanders, Barry. "Gustav Stickley: A Craftsman's Furniture," *American Art & Antiques*, July-August, 1979, pp. 46-53.

Sargent, Irene. "William Morris," *Craftsman*, I, October 1901, pp. 1-14.

Stickley, Gustav. "The Craftsman Movement: Its Origin and Growth," *Craftsman*, XXV, October 1913, pp. 17-26.

(Stickley, Gustav). "Distinction and Charm Given to the Ordinary Room by Craftsman Furniture," *Craftsman*, XXI, October 1911, pp. 105-109.

Wiencek, Henry. "Mission Furniture," *Americana*, September/October 1978, pp. 72-76.

Acknowledgments

The authors wish to express their appreciation to the many individuals who have been generous with information and illustrations for this book. The research has been so fascinating that if there had not been a deadline, work would still be progressing.

We would like to give special acknowledgment to Dr. Robert Bishop, Director of the Museum of American Folk Art, for giving encouragement and writing the introduction; to Beth Cathers who answered many a question and who allowed us to photograph her fine collection; to Ellen Ente who took her first "house" pictures for us.

We thank the following for allowing us to reproduce photographs: Allison M. Eckardt, Assistant to the Editor of *The Magazine Antiques*; Mrs. Deborah D. Waters, Librarian and Dr. Frank H. Sommer, Head of the Library, Winterthur Museum; Beth Cathers, Todd M. Volpe and Vance Jordan of the Jordan-Volpe Gallery in New York City; William Seale, author of *The Tasteful Interlude*; Robert Edwards of the Robert Edwards Gallery in Rosemont, Pennsylvania; Randell L. Makinson, Director of The Gamble House; the William Morris Gallery; Stephen Estock of Venturi and Rauch; and Kenneth Wilson, Director of the Henry Ford Museum.

We express our appreciation to John W. Cutler of the Providence Art Club and to Joan Wells and Eve Utne of the Victorian Society of America, for carrying on a lively correspondence with us.

Special mention must be made to those who shared their homes with us: Sandra Brant, Beth Cathers and Joan Dillof and their families.

About the Authors

Cynthia and Jerome Rubin's interest in the development of modern design stems from their long involvement with Shaker artifacts and history. Their expertise in Shaker design and crafts emerged in their recent book, *Shaker Miniature Furniture*. Cynthia was recently Visiting Curator of the 1979 Shaker exhibition at the Museum of American Folk Art in New York City.

Cynthia received an A.B. from Vassar College and an Ed.M. from Boston University. Jerome Rubin received a B.A. from Northeastern University. The Rubins live in Boston and are the authors of a number of Boston guidebooks and cookbooks.